KERBY'S SELECTION
WONDROUS ANIMALS
Color a Kingdom of Creatures

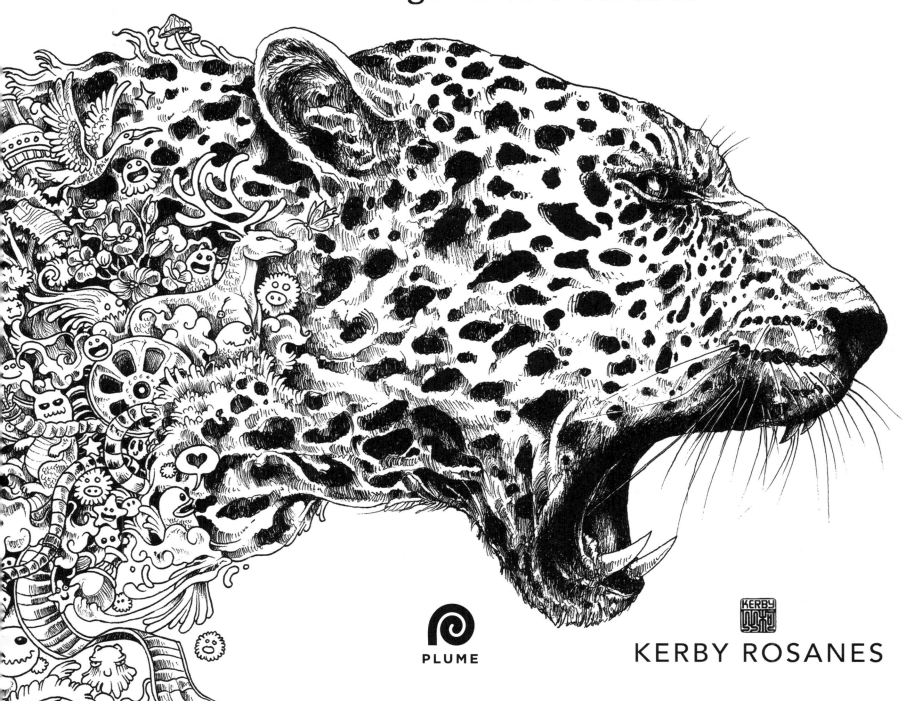

PLUME

KERBY ROSANES

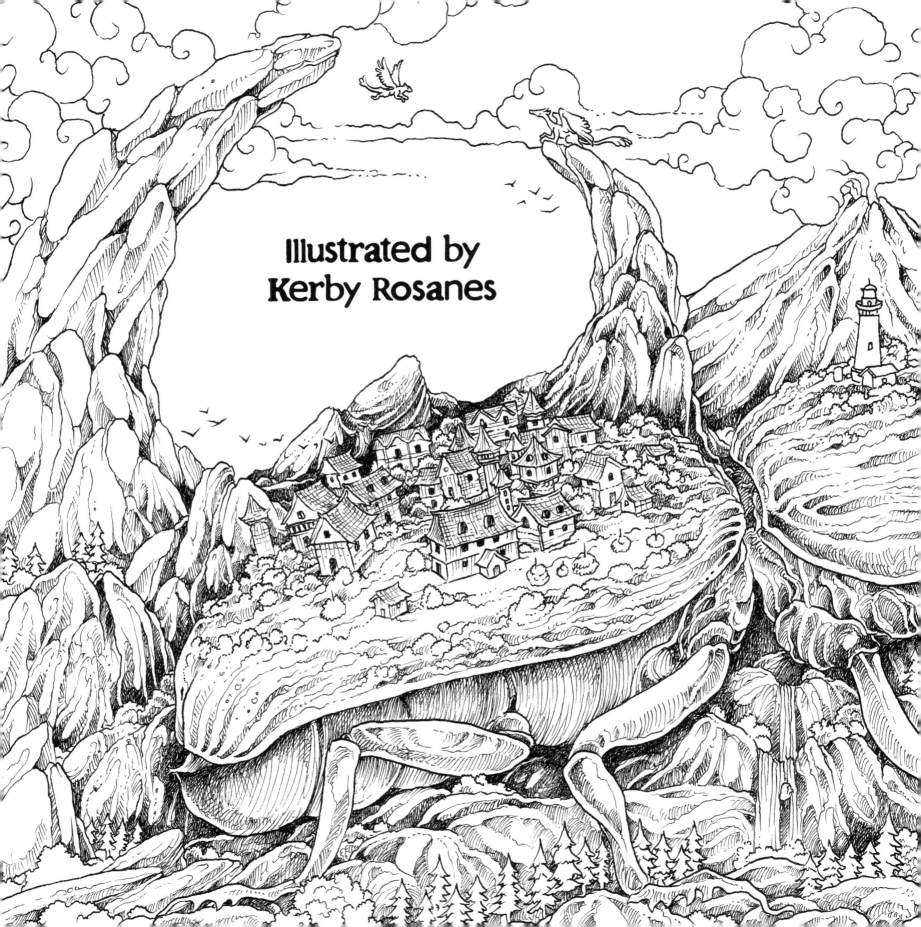

Illustrated by
Kerby Rosanes

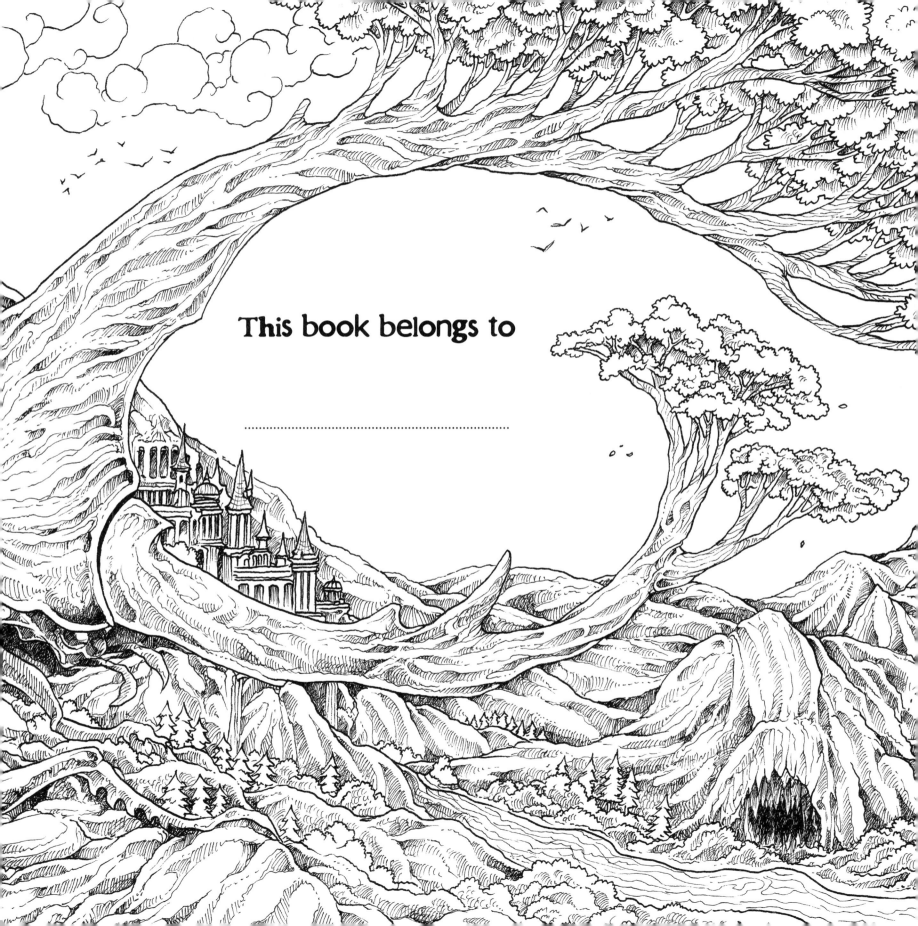

This book belongs to

...

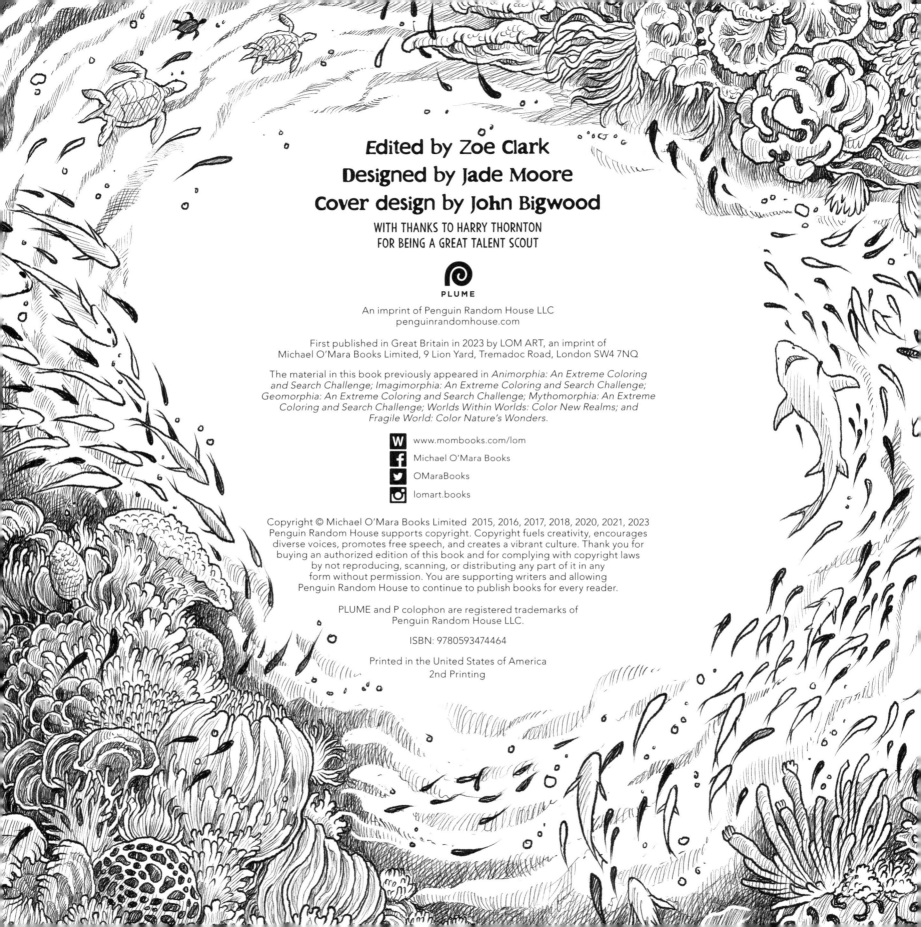

Edited by Zoe Clark
Designed by Jade Moore
Cover design by John Bigwood

WITH THANKS TO HARRY THORNTON
FOR BEING A GREAT TALENT SCOUT

PLUME

An imprint of Penguin Random House LLC
penguinrandomhouse.com

First published in Great Britain in 2023 by LOM ART, an imprint of
Michael O'Mara Books Limited, 9 Lion Yard, Tremadoc Road, London SW4 7NQ

The material in this book previously appeared in *Animorphia: An Extreme Coloring
and Search Challenge*; *Imagimorphia: An Extreme Coloring and Search Challenge*;
Geomorphia: An Extreme Coloring and Search Challenge; *Mythomorphia: An Extreme
Coloring and Search Challenge*; *Worlds Within Worlds: Color New Realms*; and
Fragile World: Color Nature's Wonders.

W www.mombooks.com/lom
f Michael O'Mara Books
t OMaraBooks
i lomart.books

ISBN: 9780593474464

Printed in the United States of America
2nd Printing

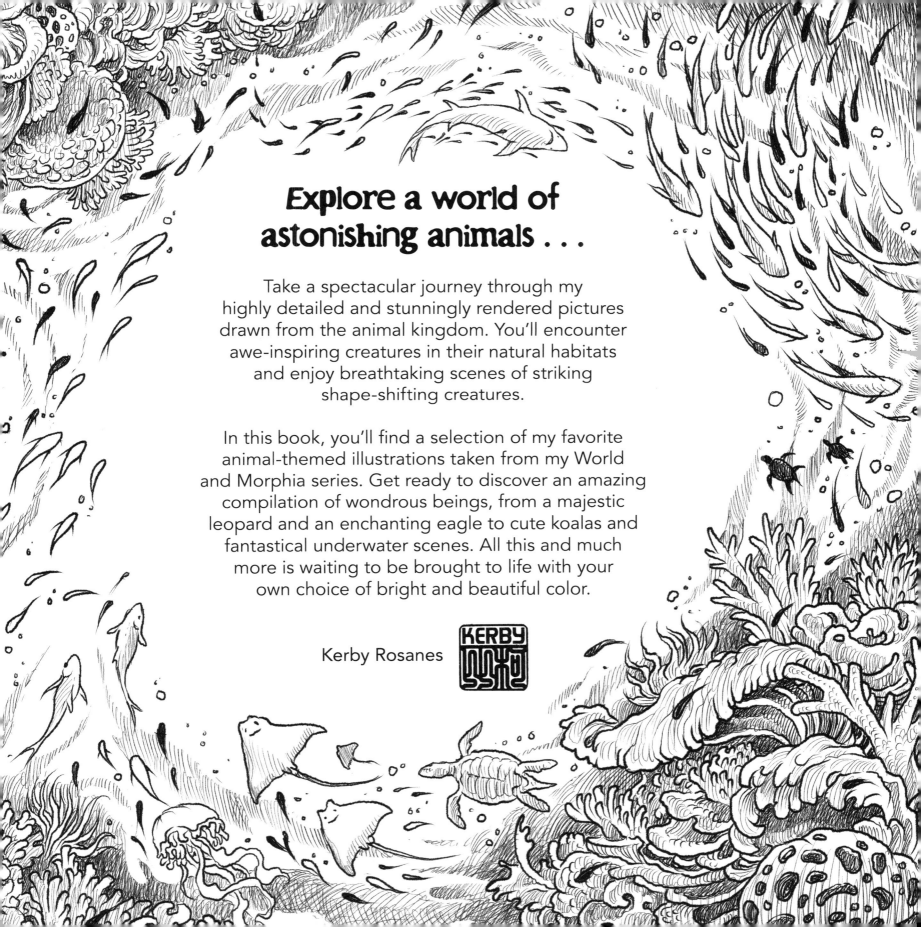

Explore a world of astonishing animals . . .

Take a spectacular journey through my highly detailed and stunningly rendered pictures drawn from the animal kingdom. You'll encounter awe-inspiring creatures in their natural habitats and enjoy breathtaking scenes of striking shape-shifting creatures.

In this book, you'll find a selection of my favorite animal-themed illustrations taken from my World and Morphia series. Get ready to discover an amazing compilation of wondrous beings, from a majestic leopard and an enchanting eagle to cute koalas and fantastical underwater scenes. All this and much more is waiting to be brought to life with your own choice of bright and beautiful color.

Kerby Rosanes

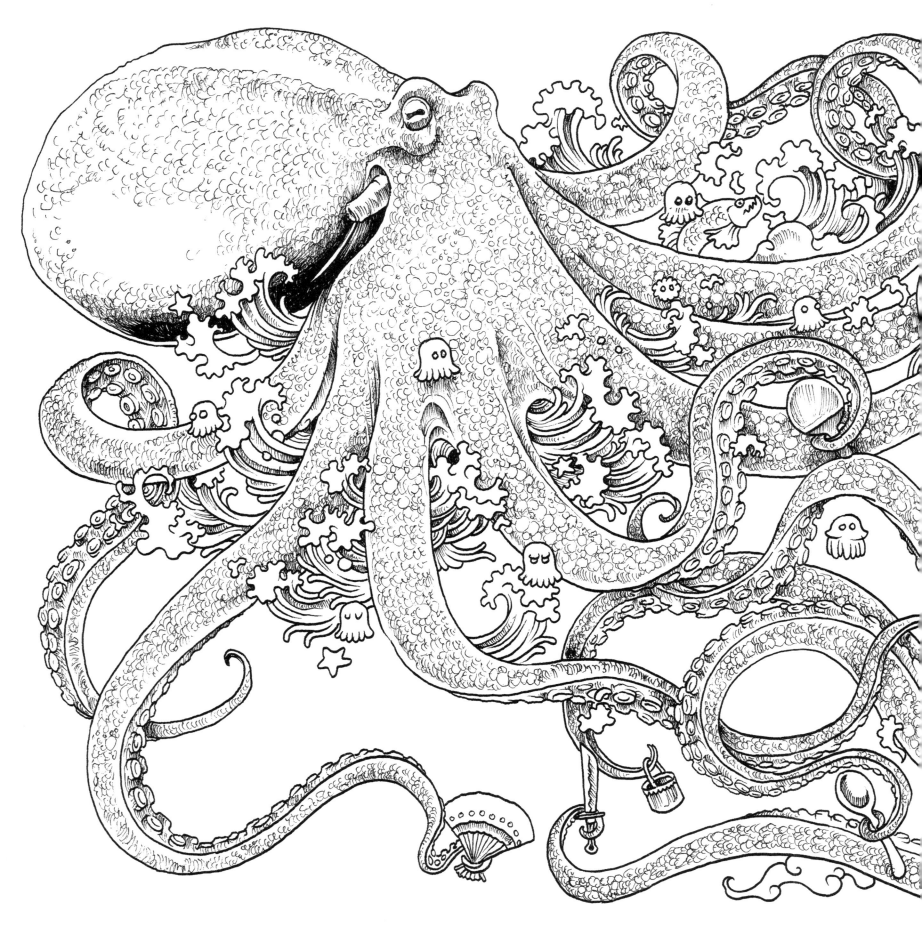

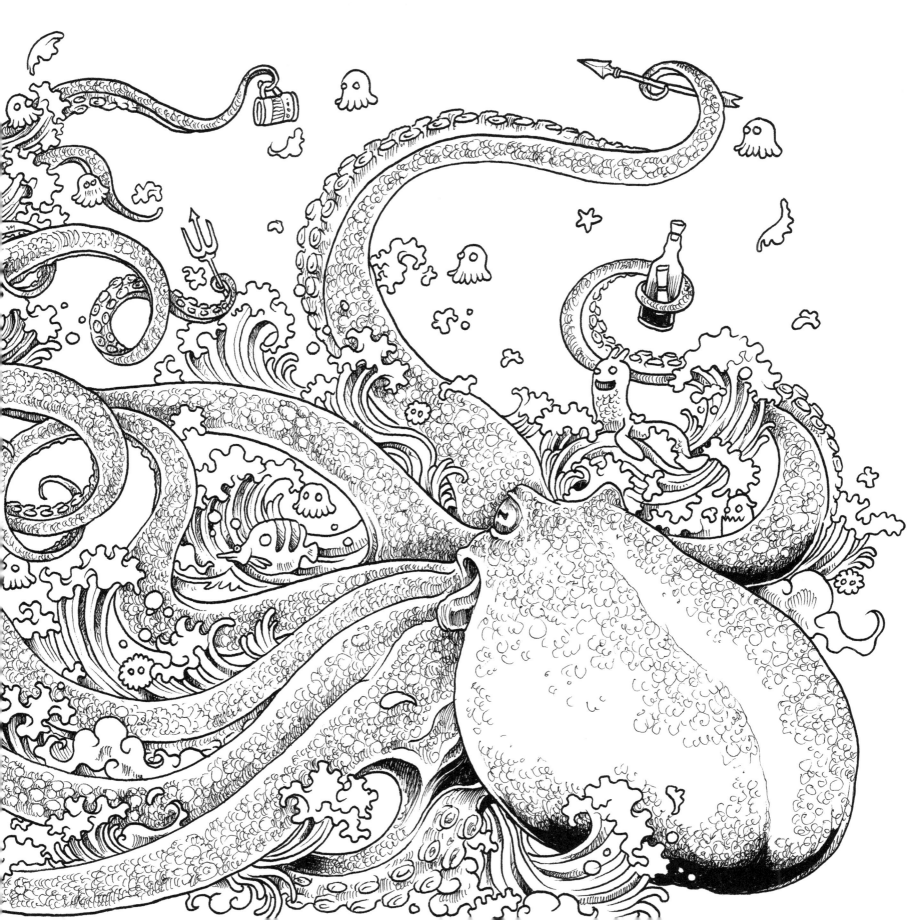

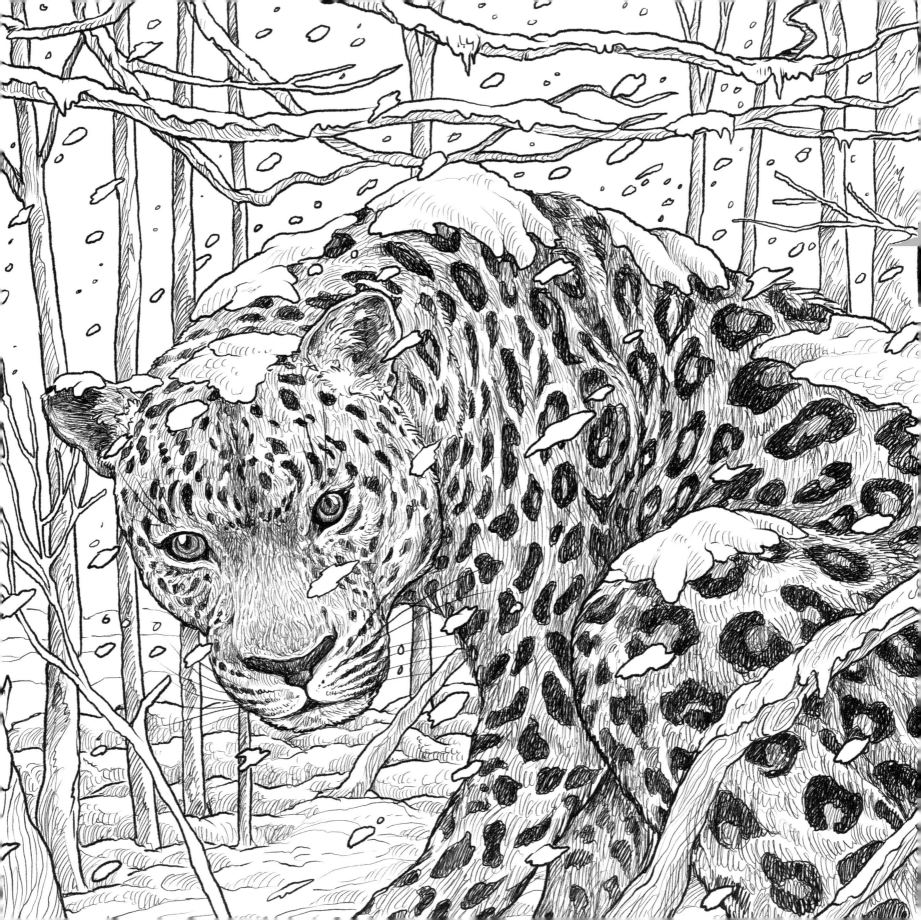

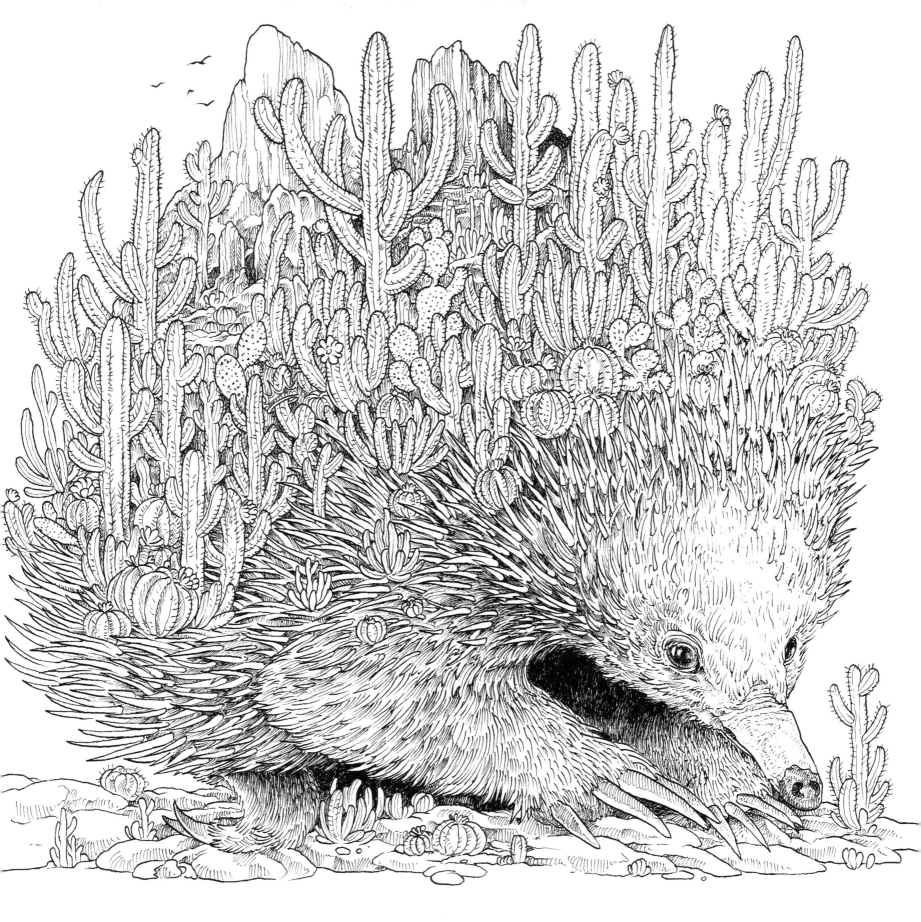

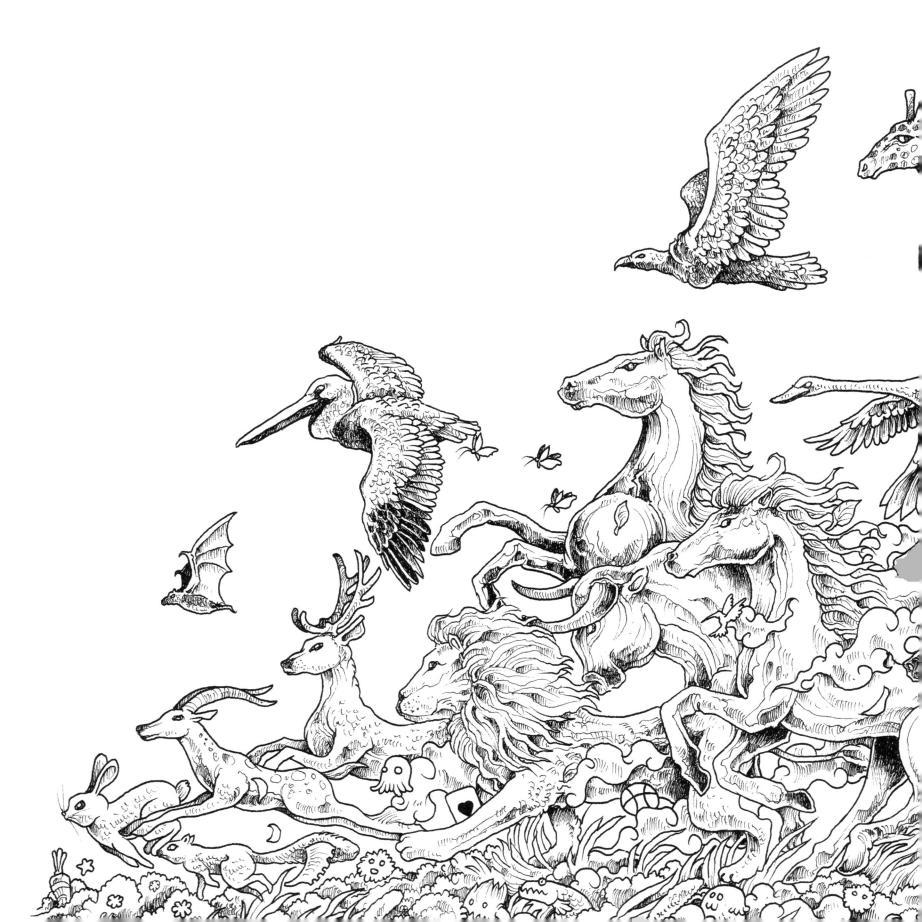

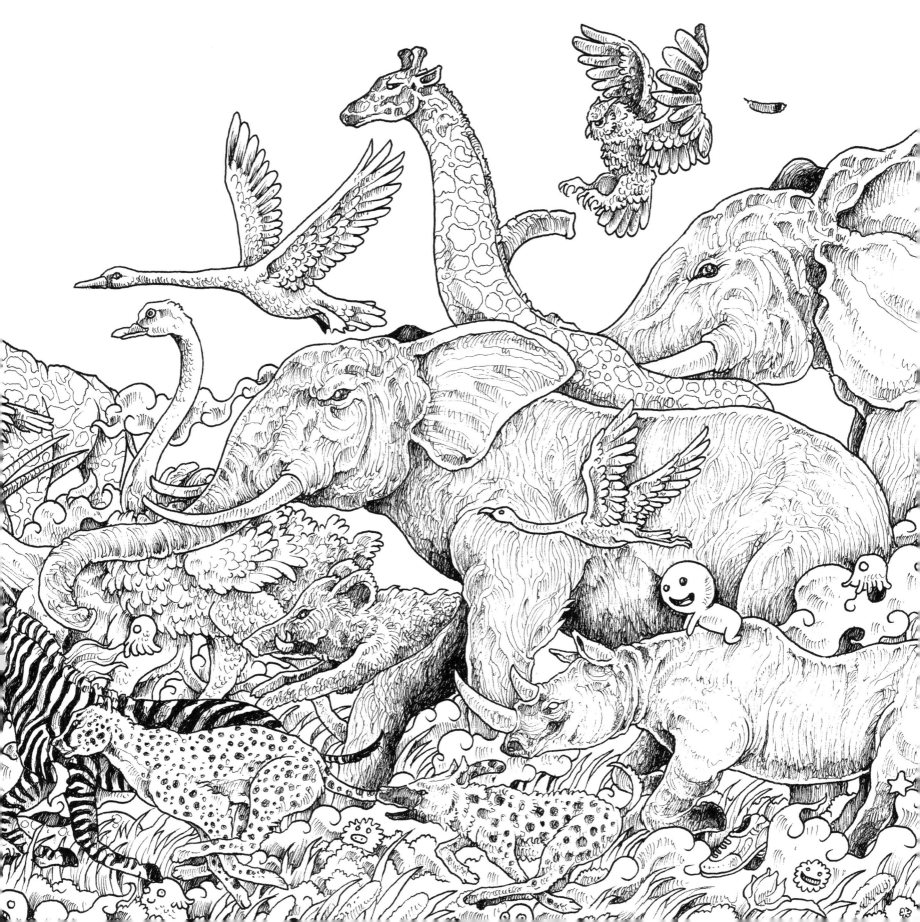

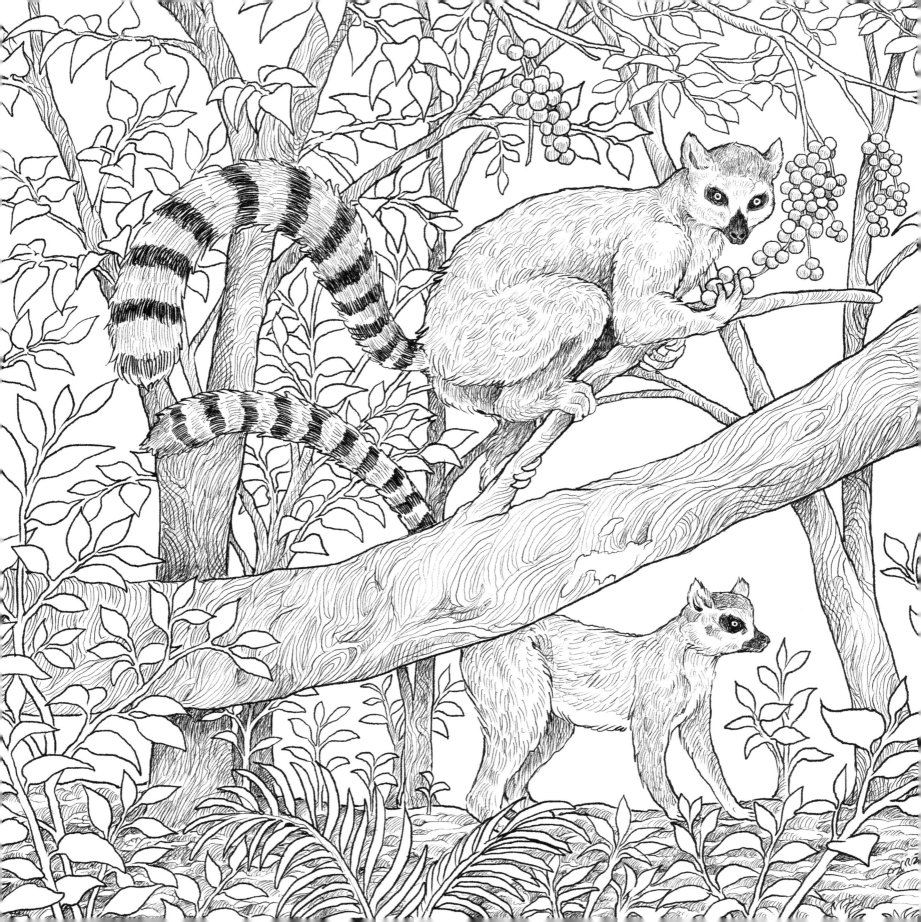

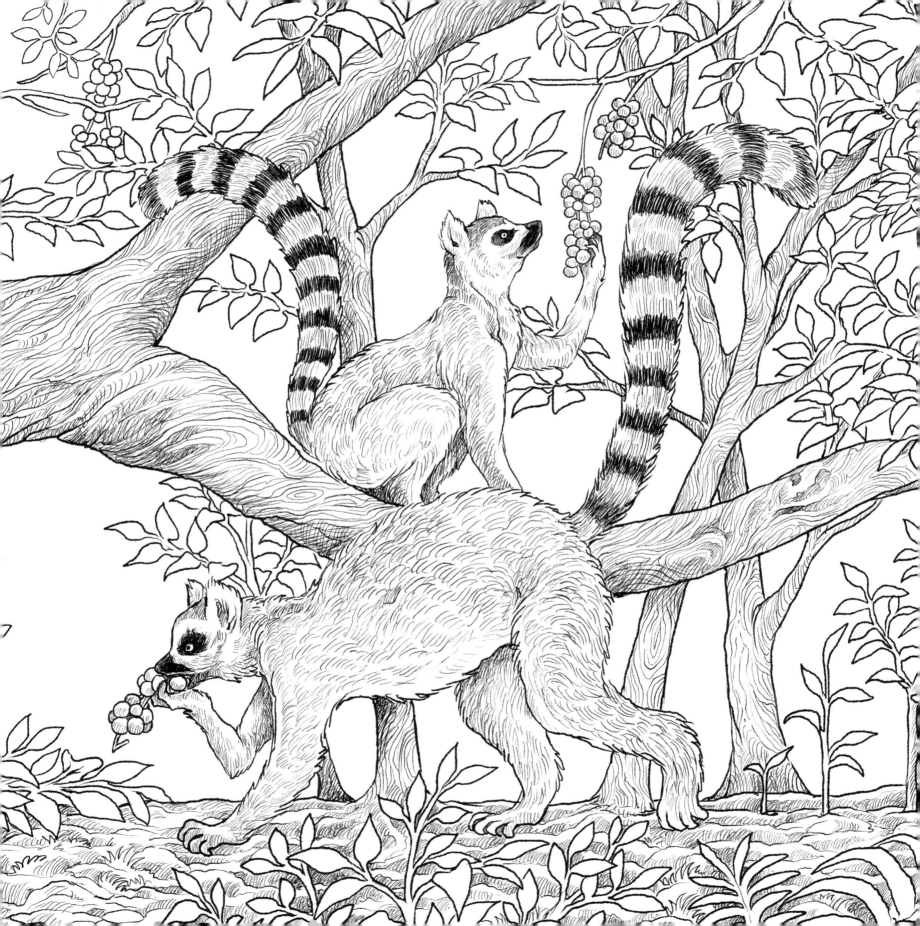

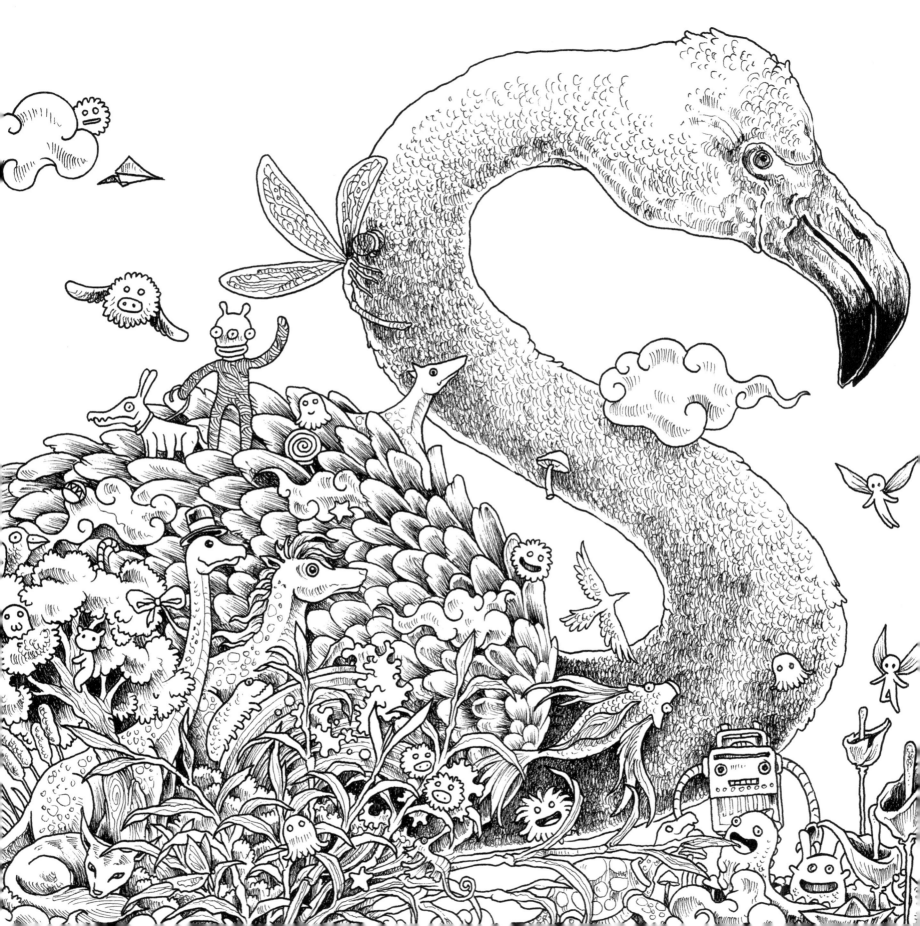

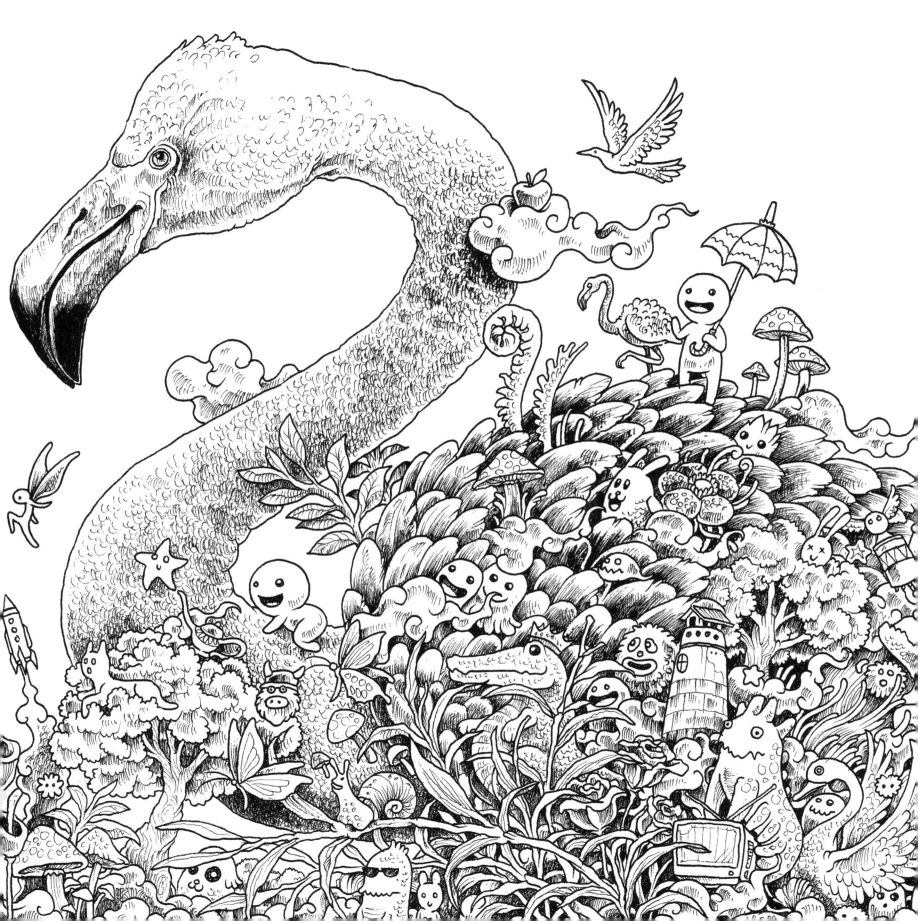

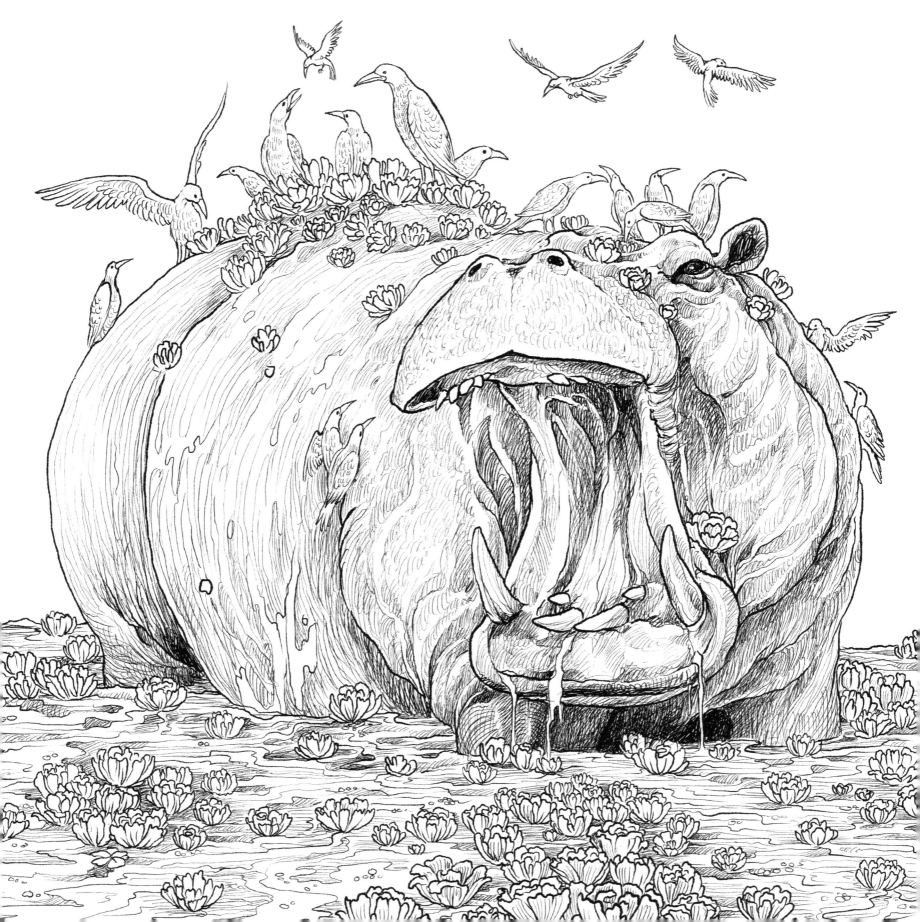

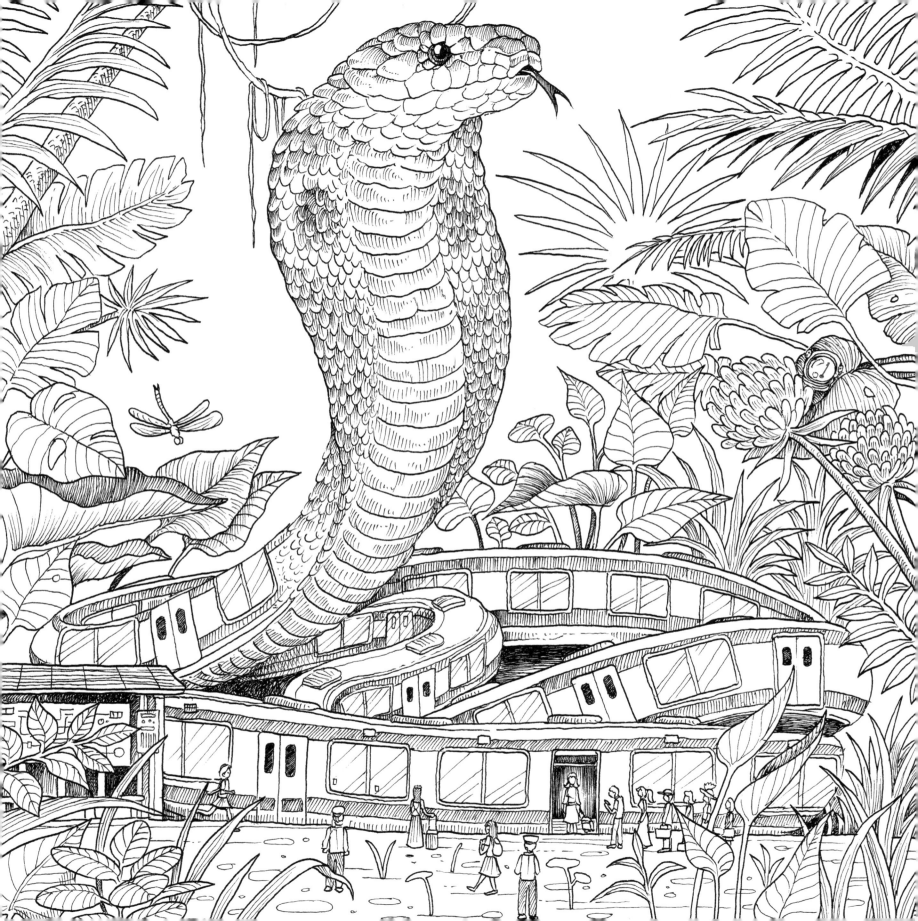

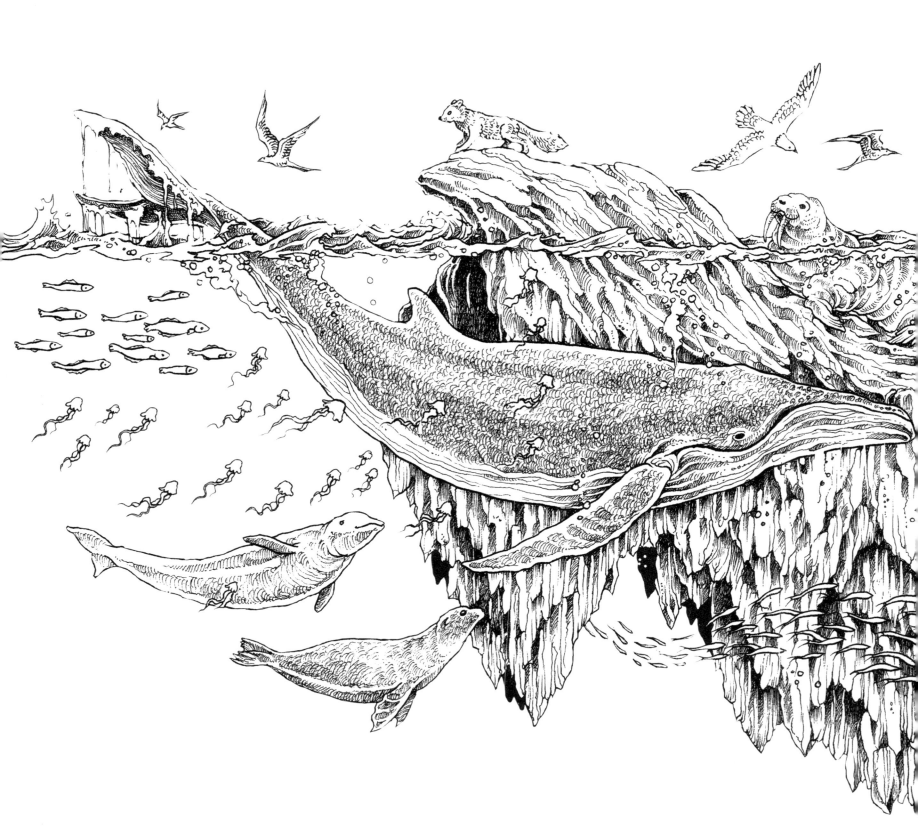

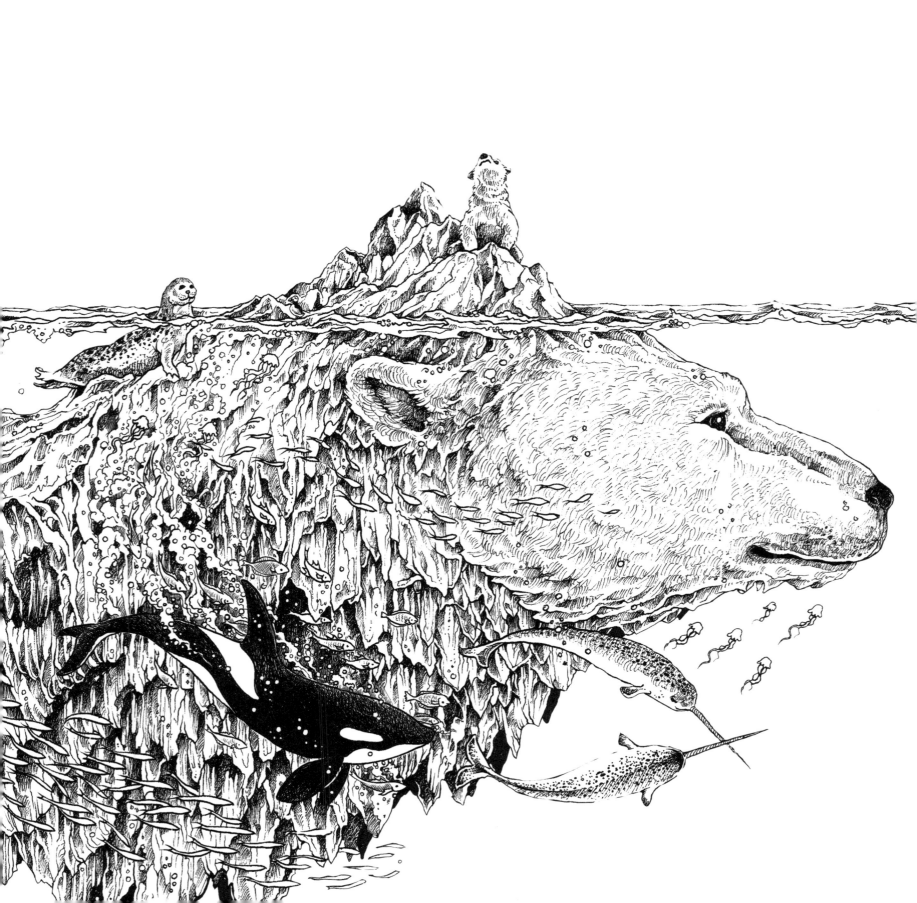

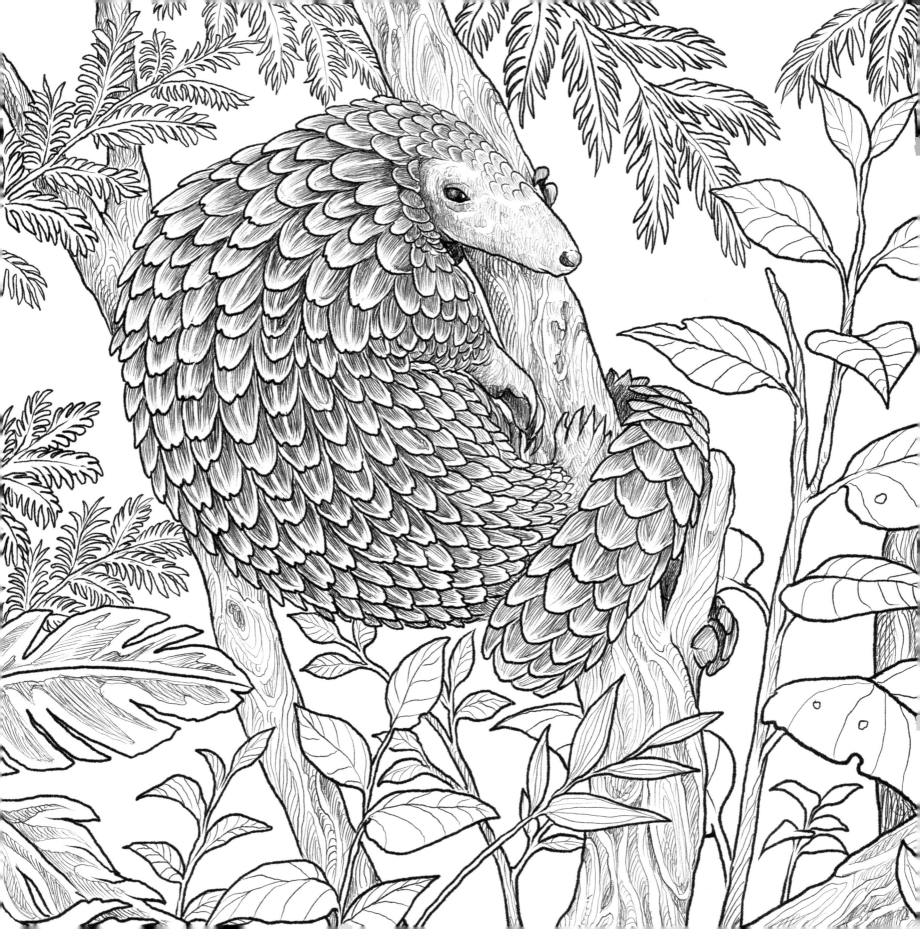

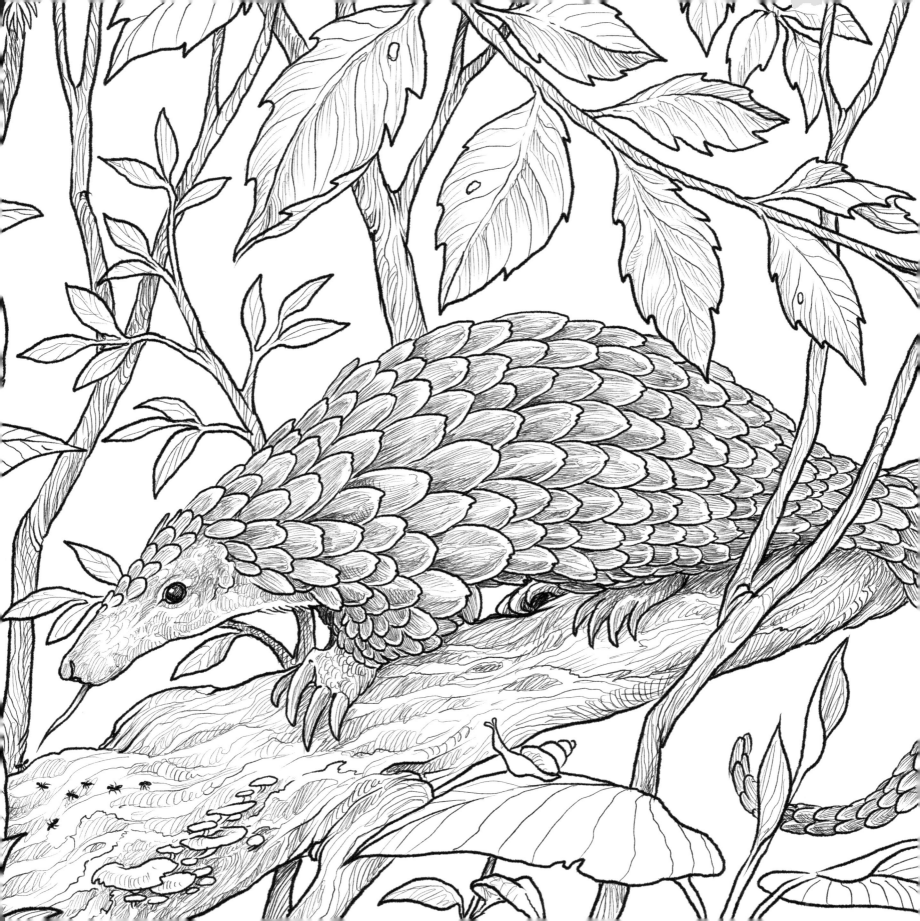

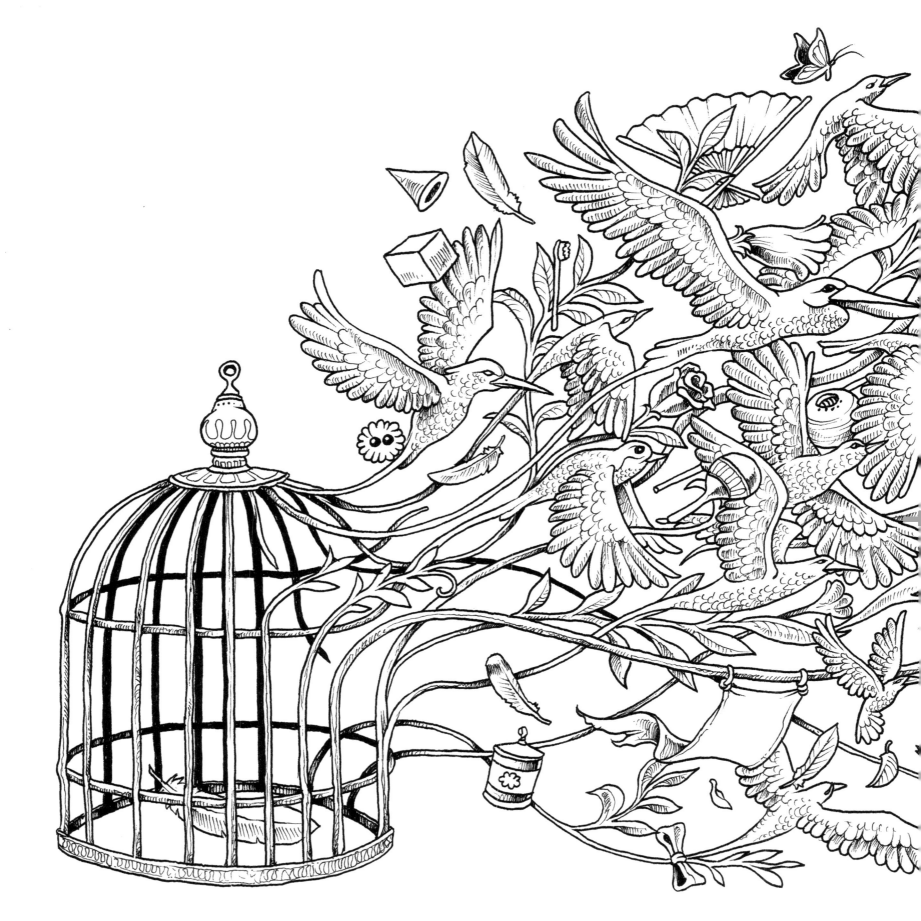

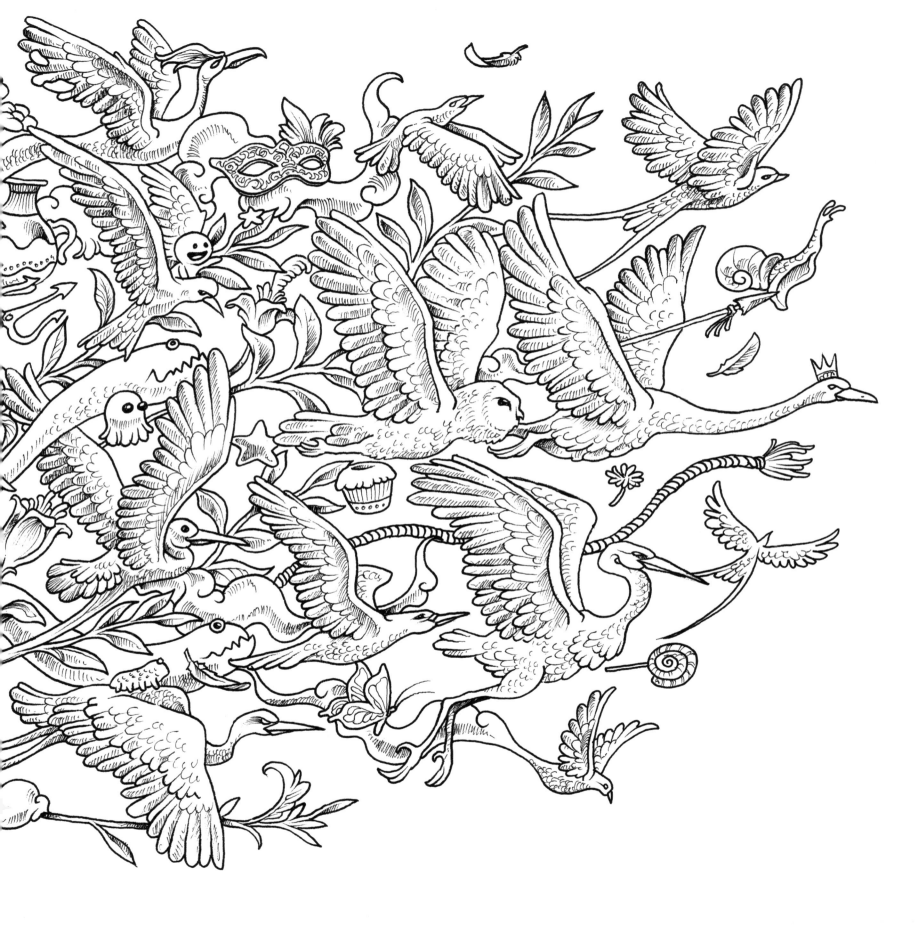

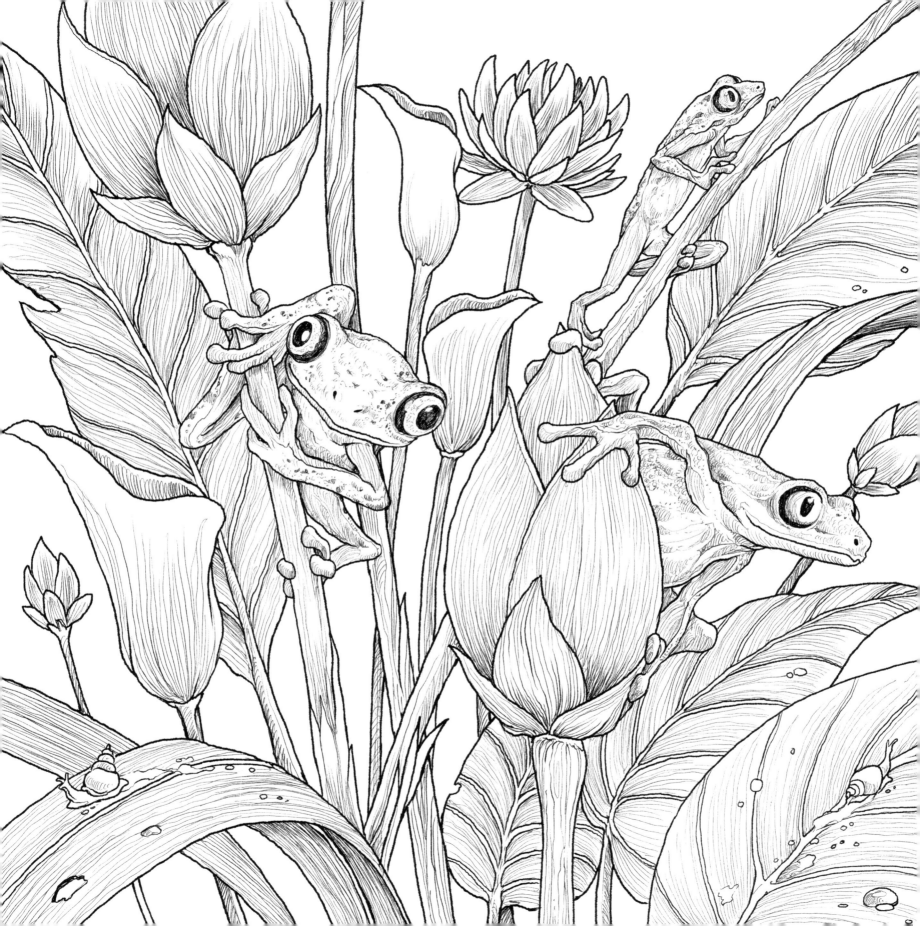

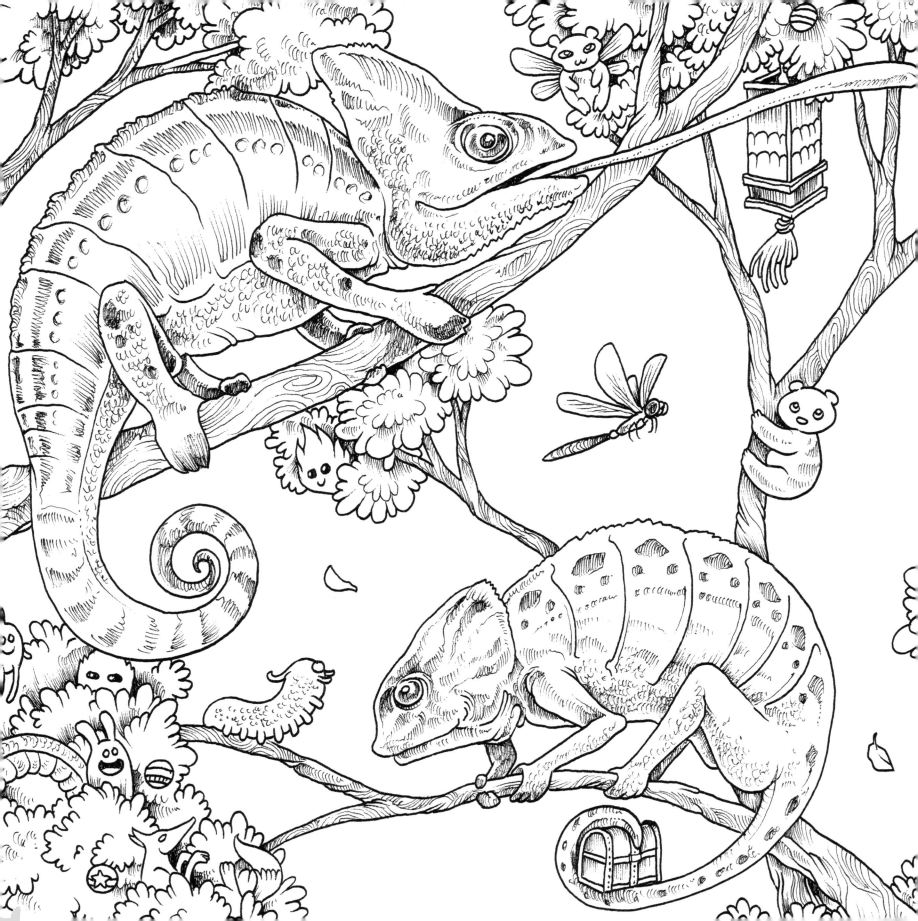

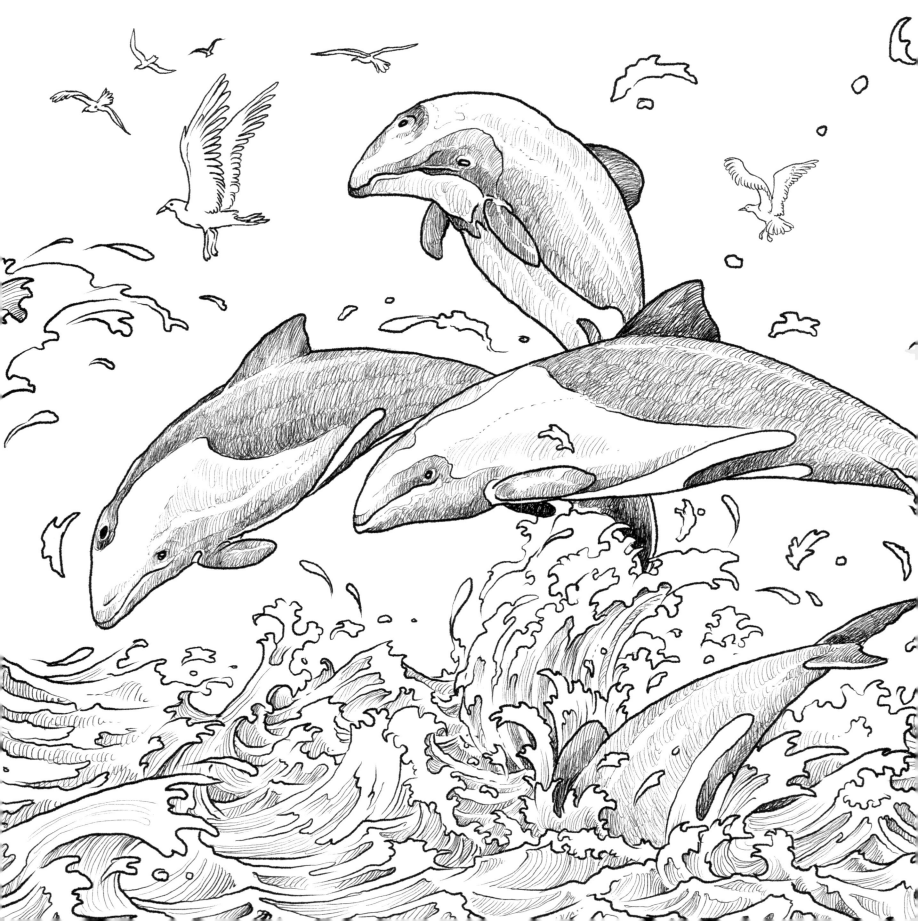

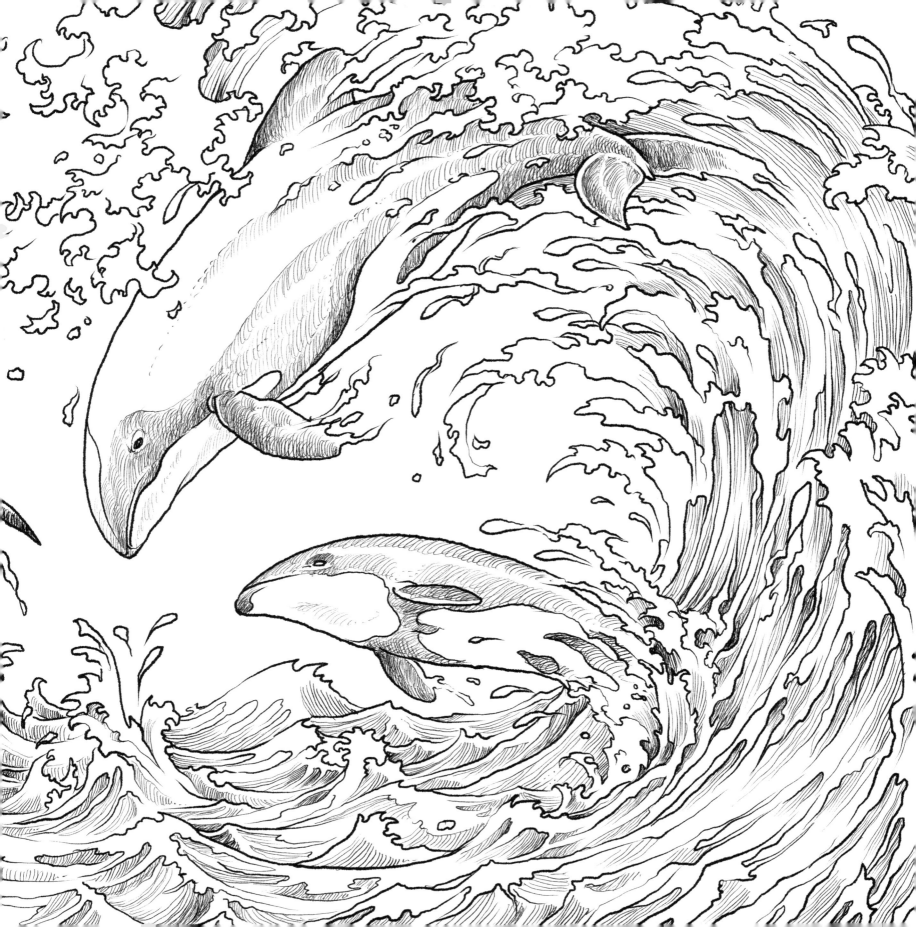

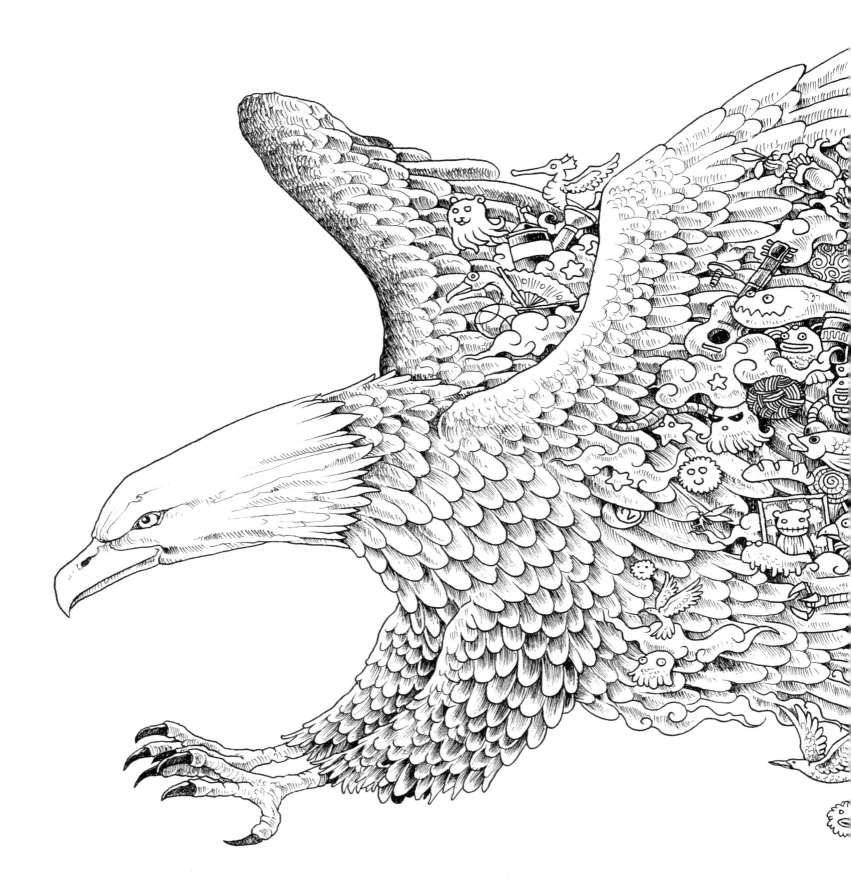

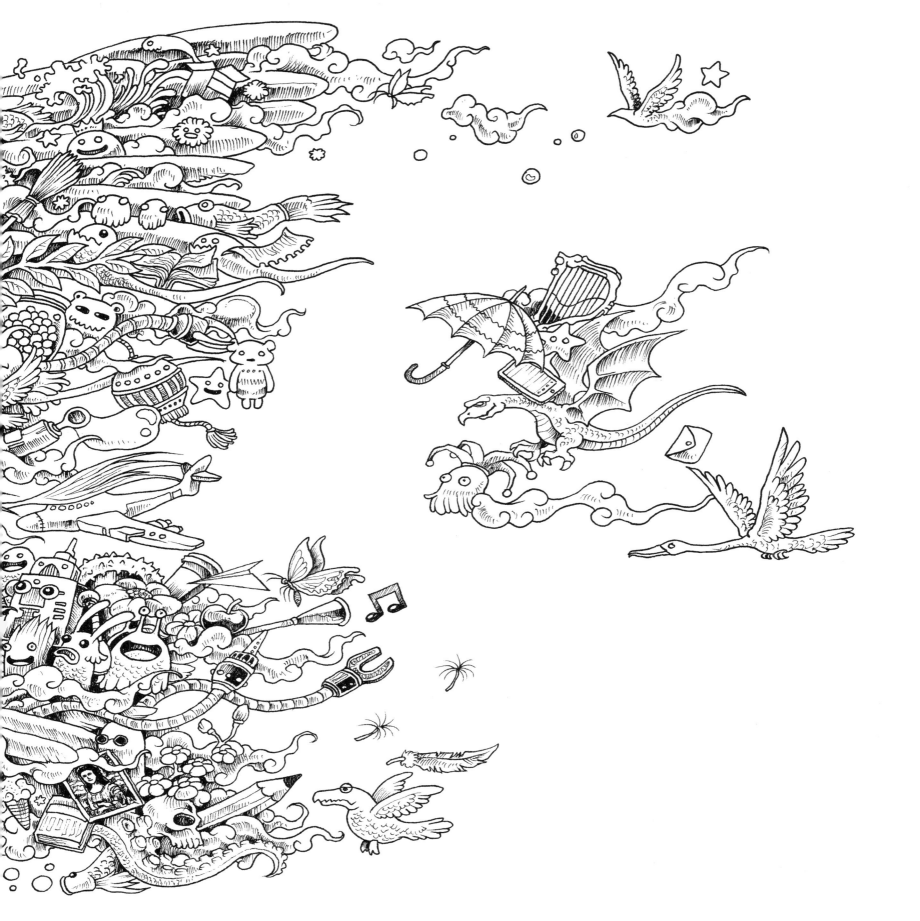

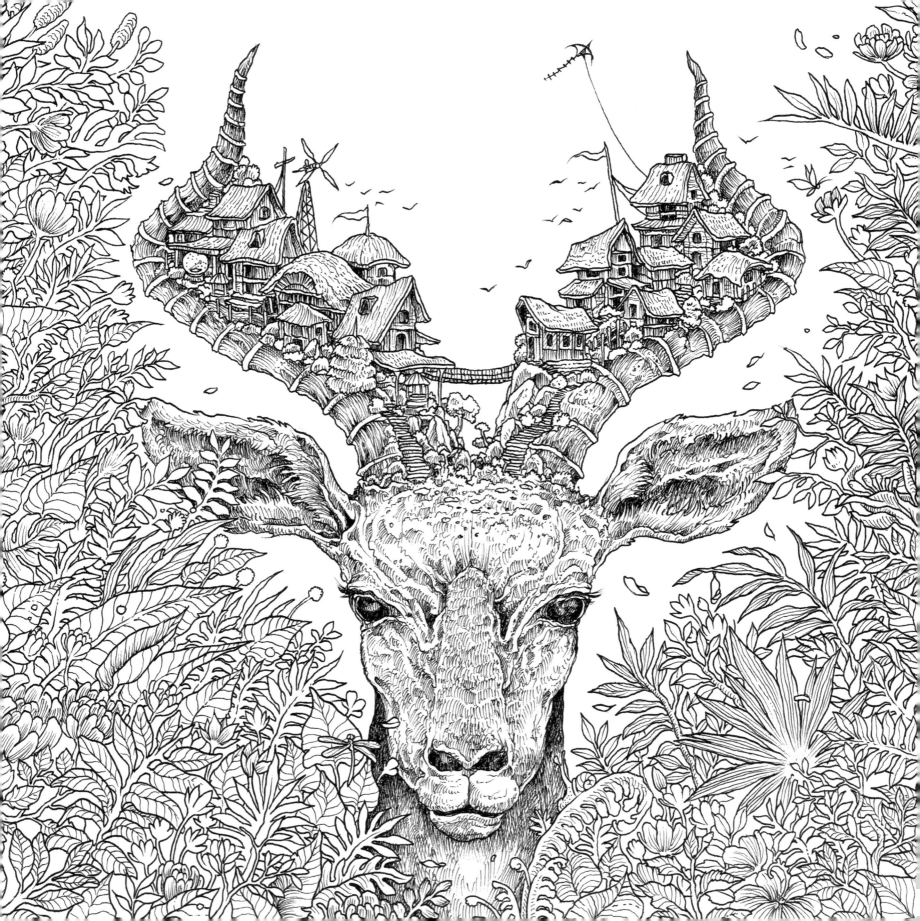

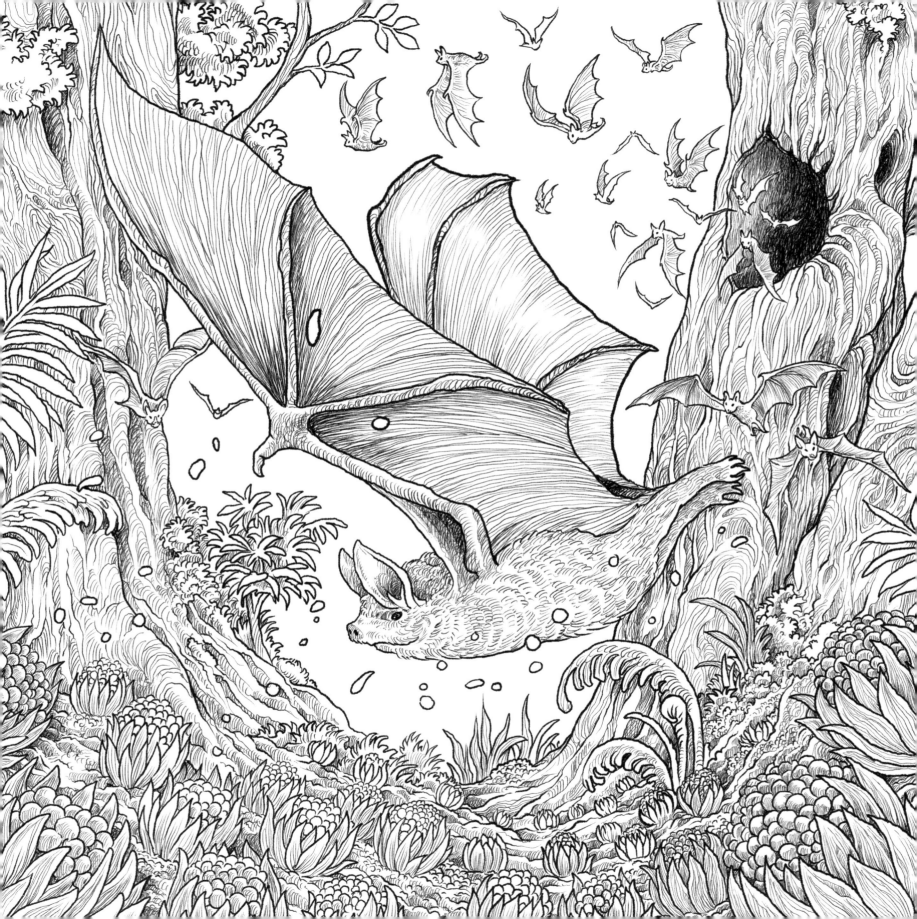

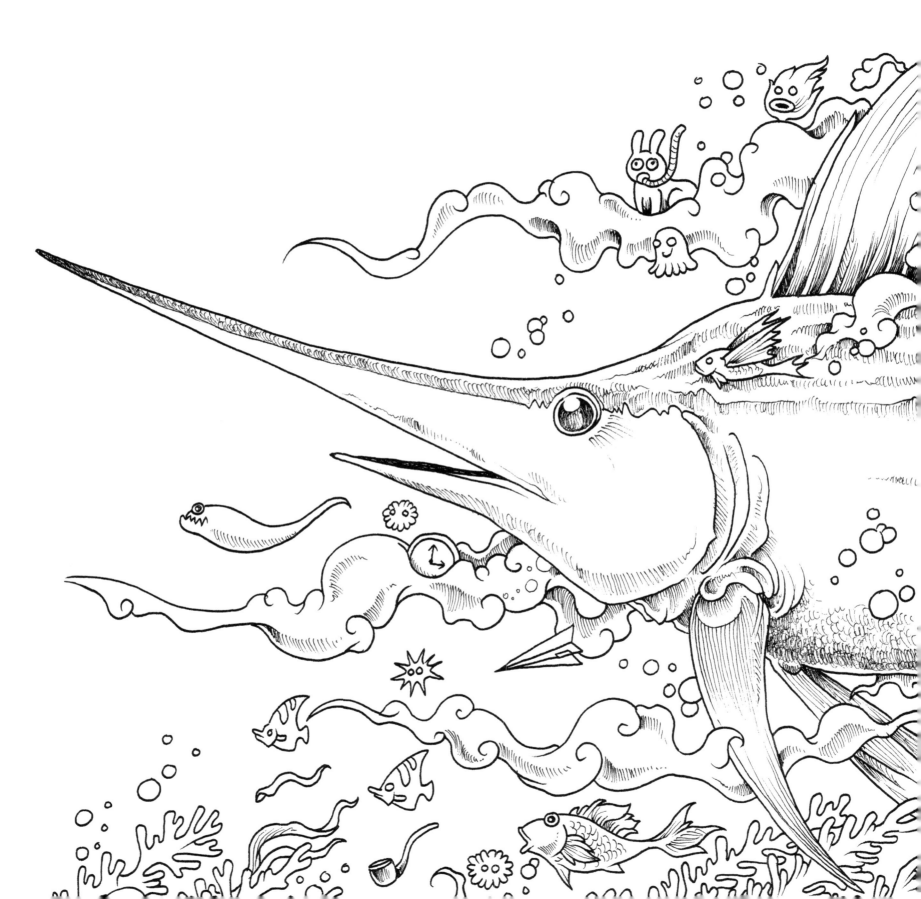

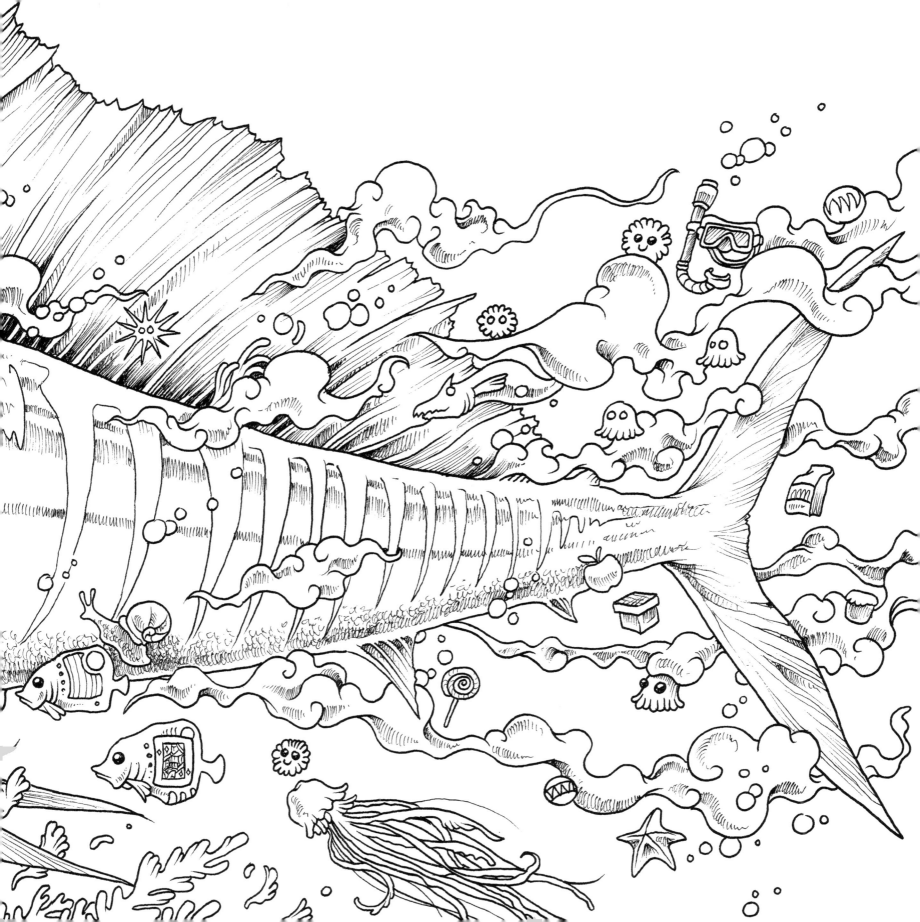

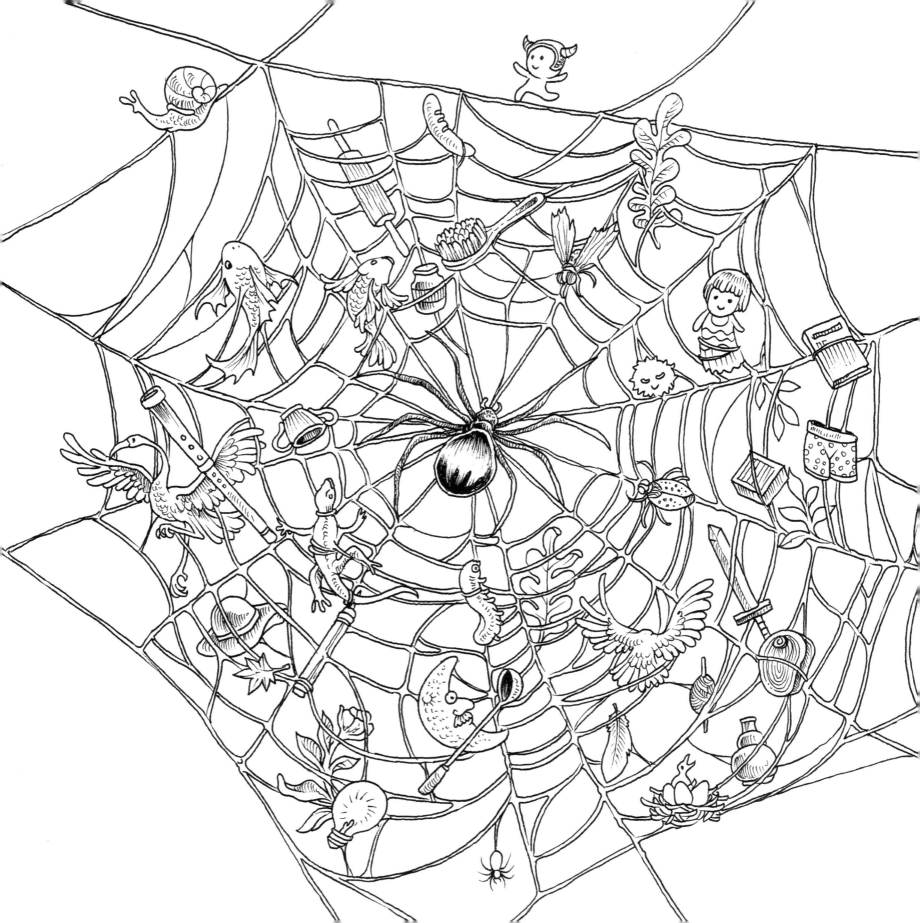

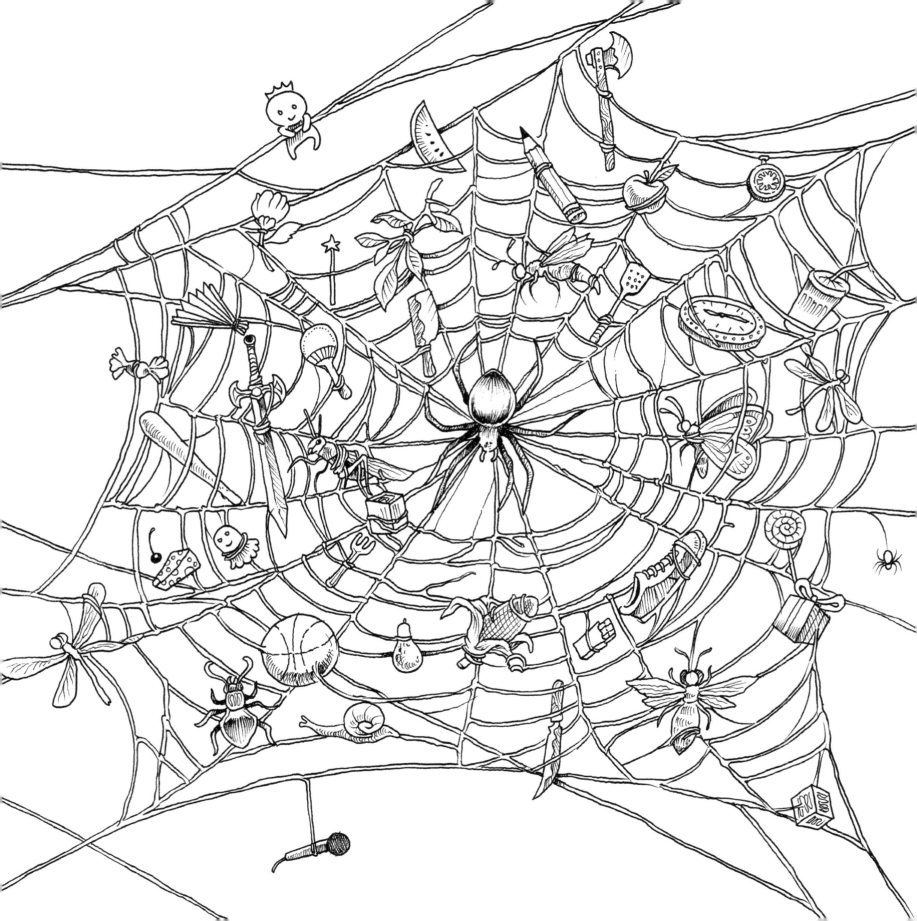

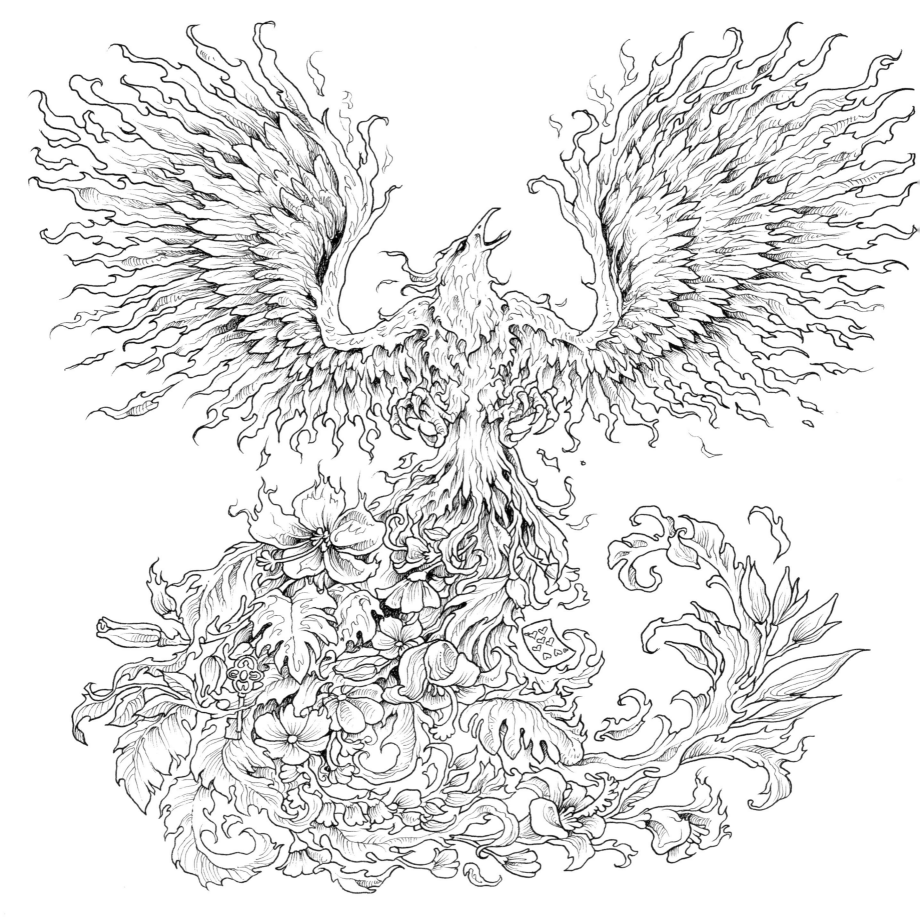

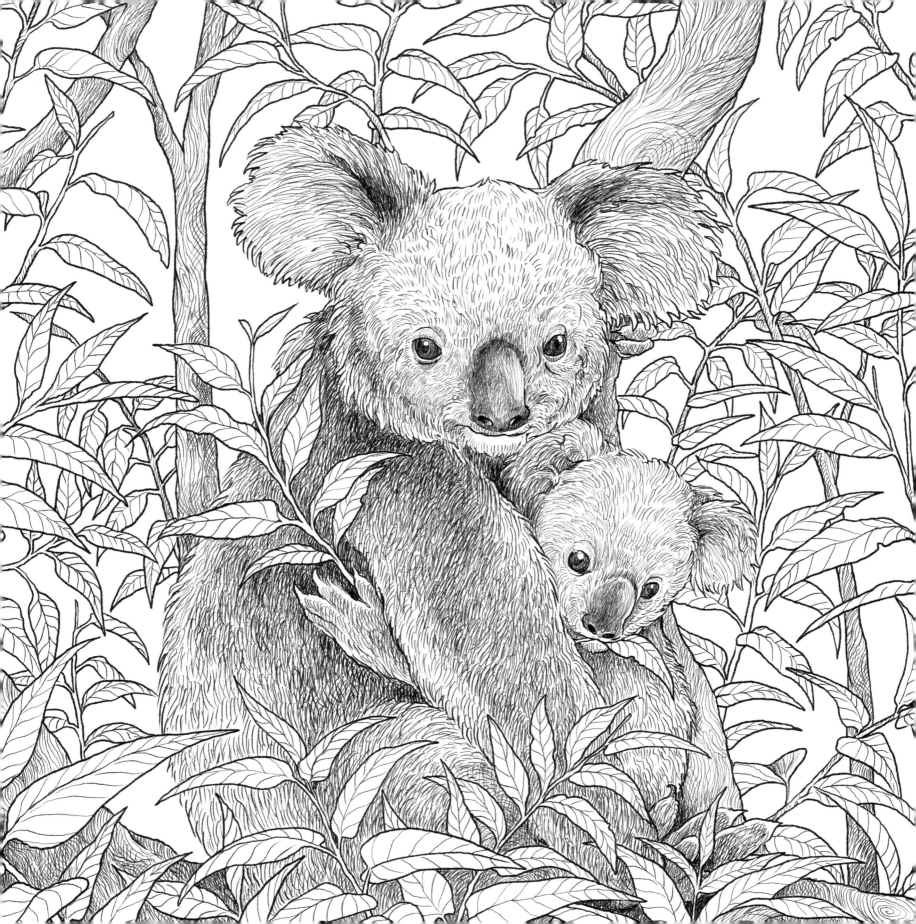

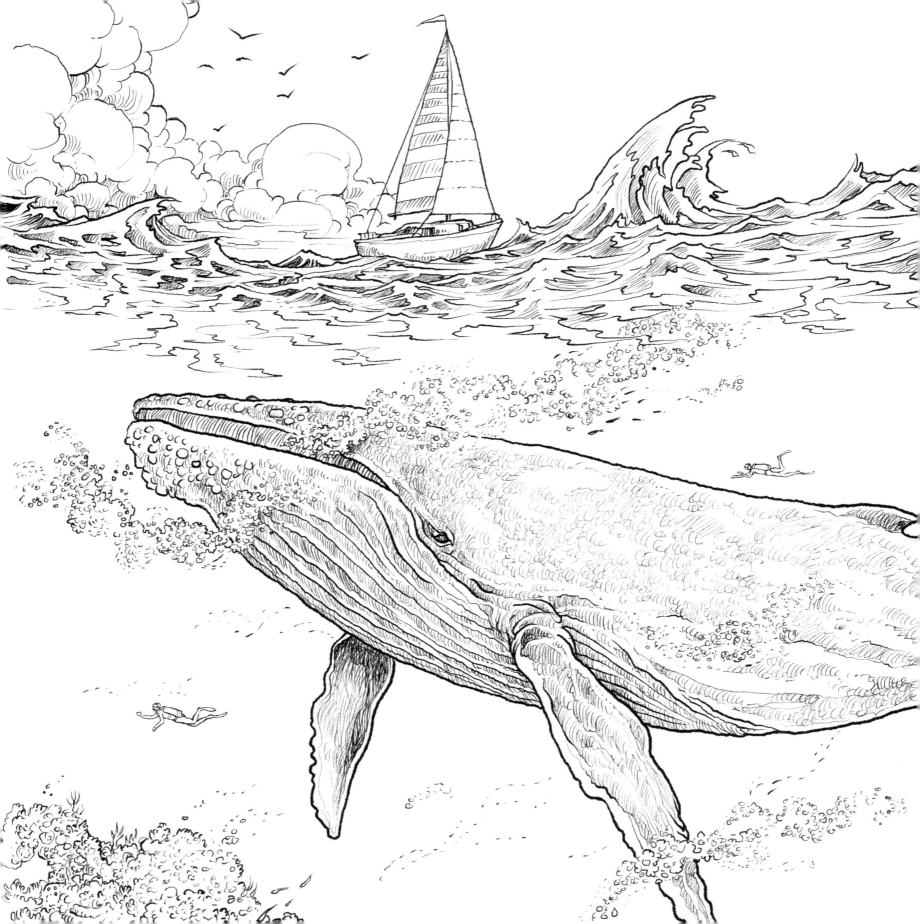

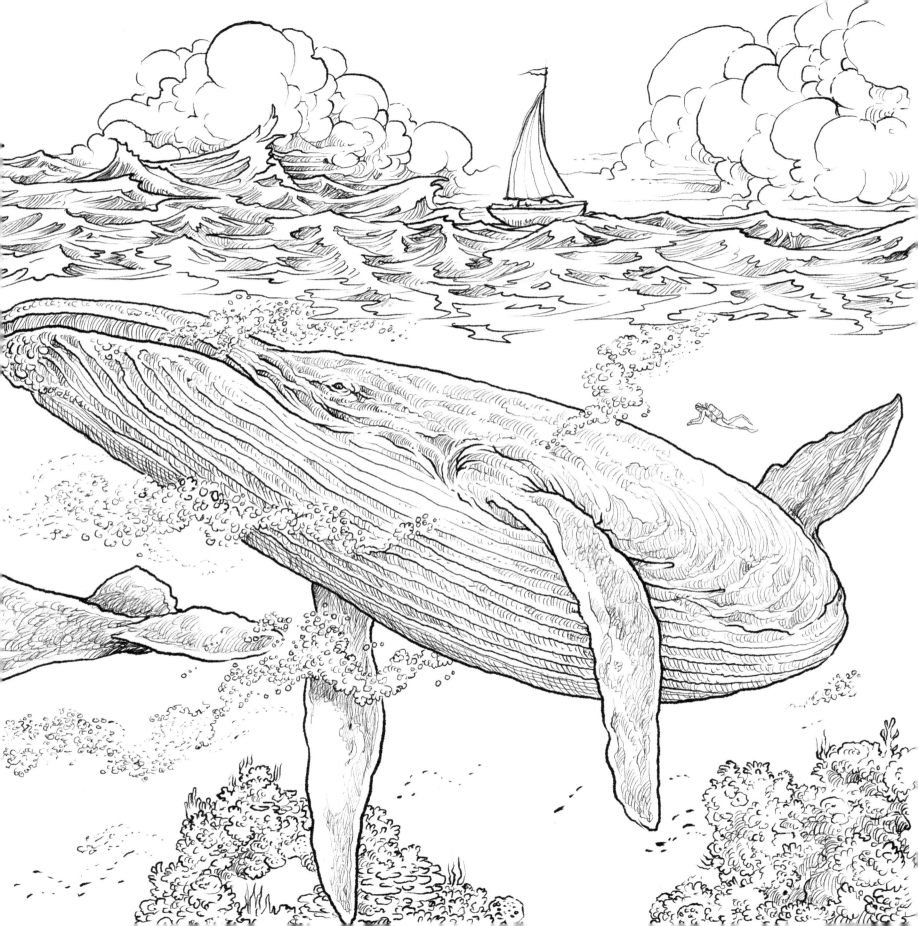

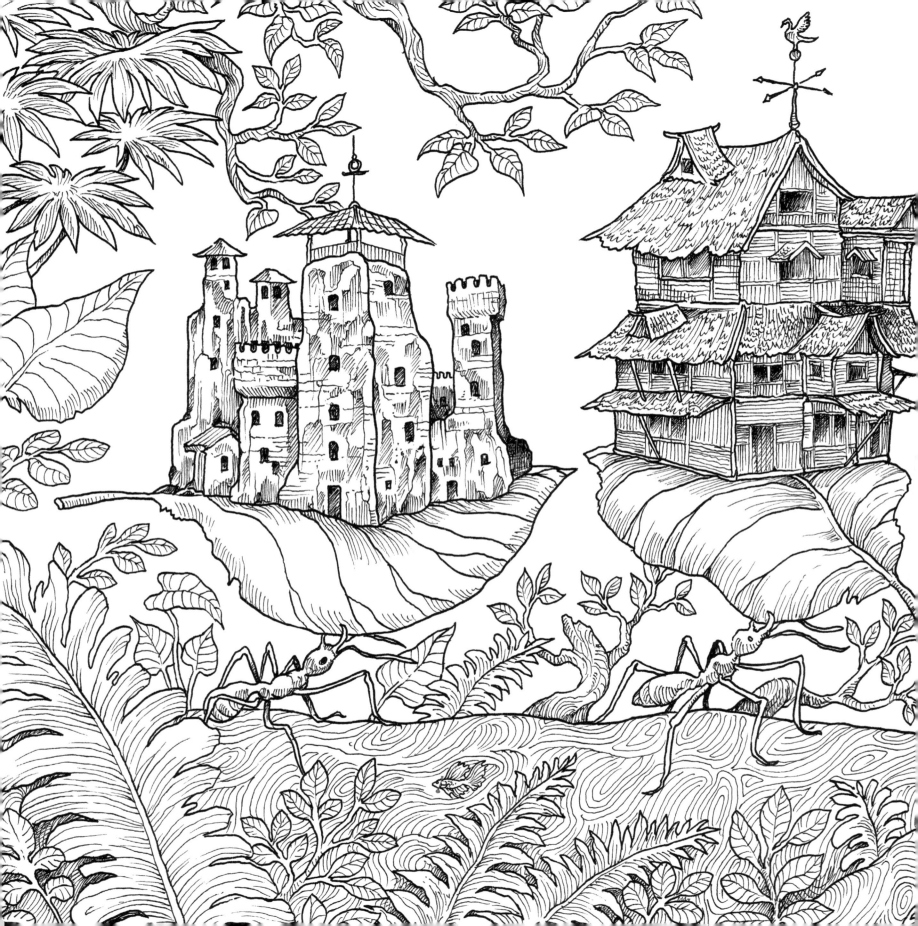

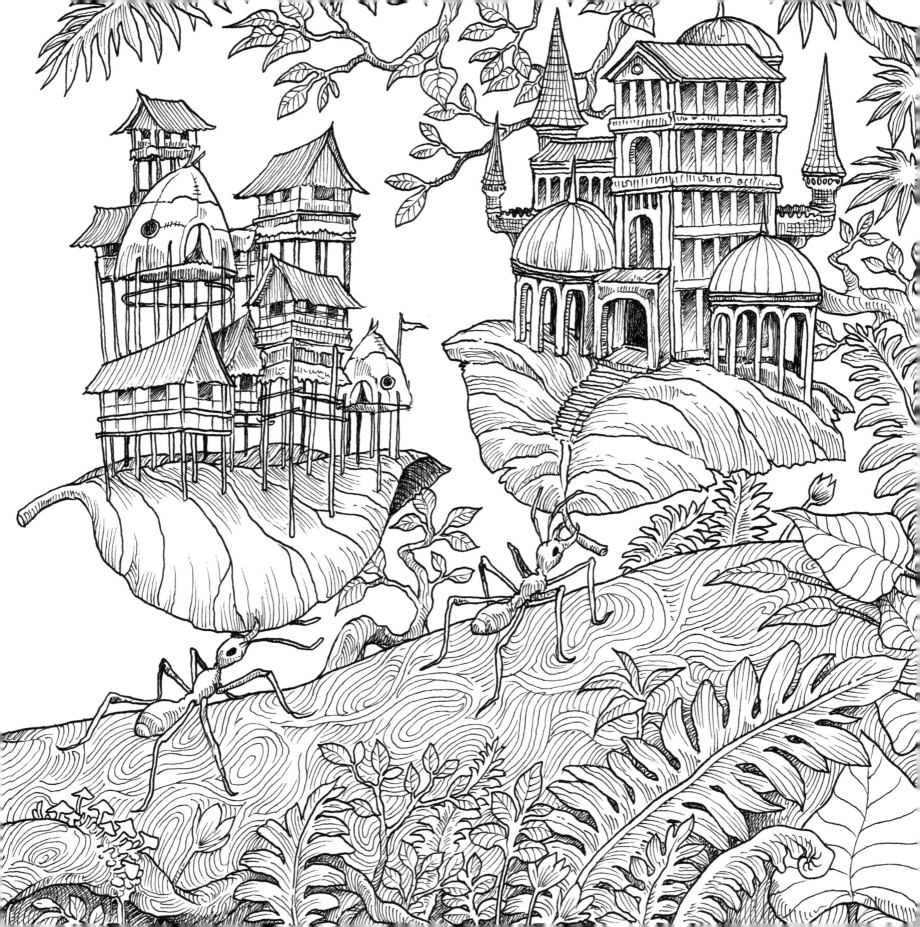

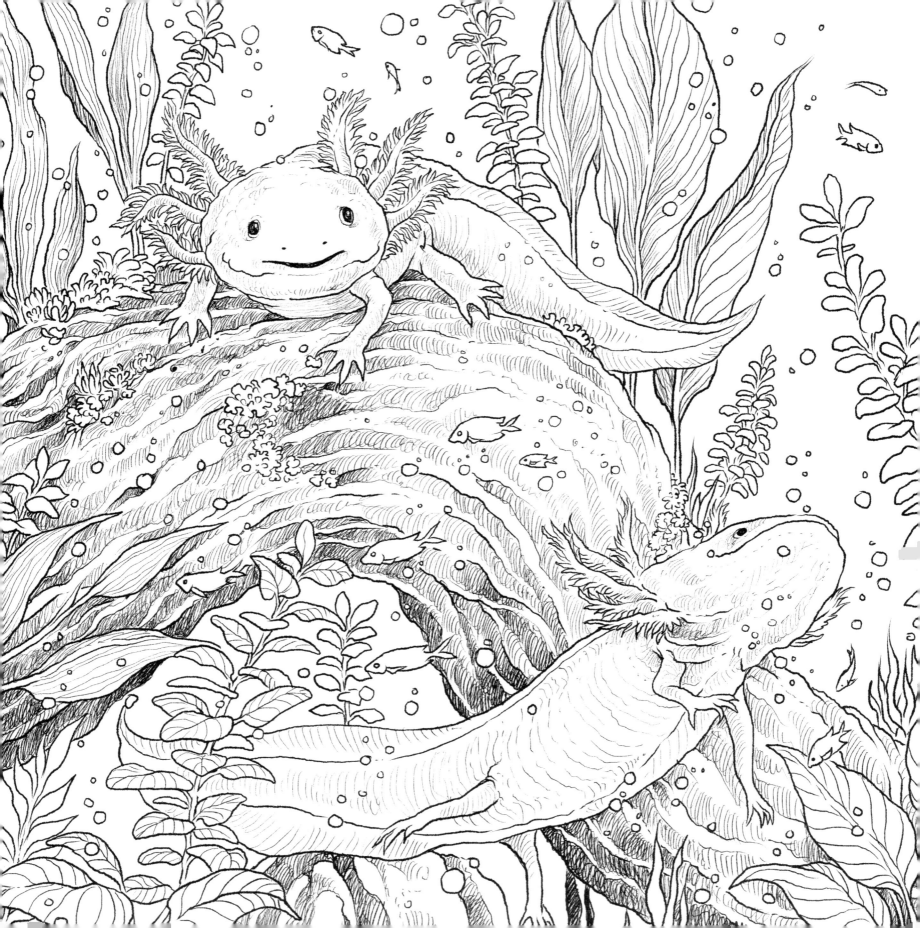

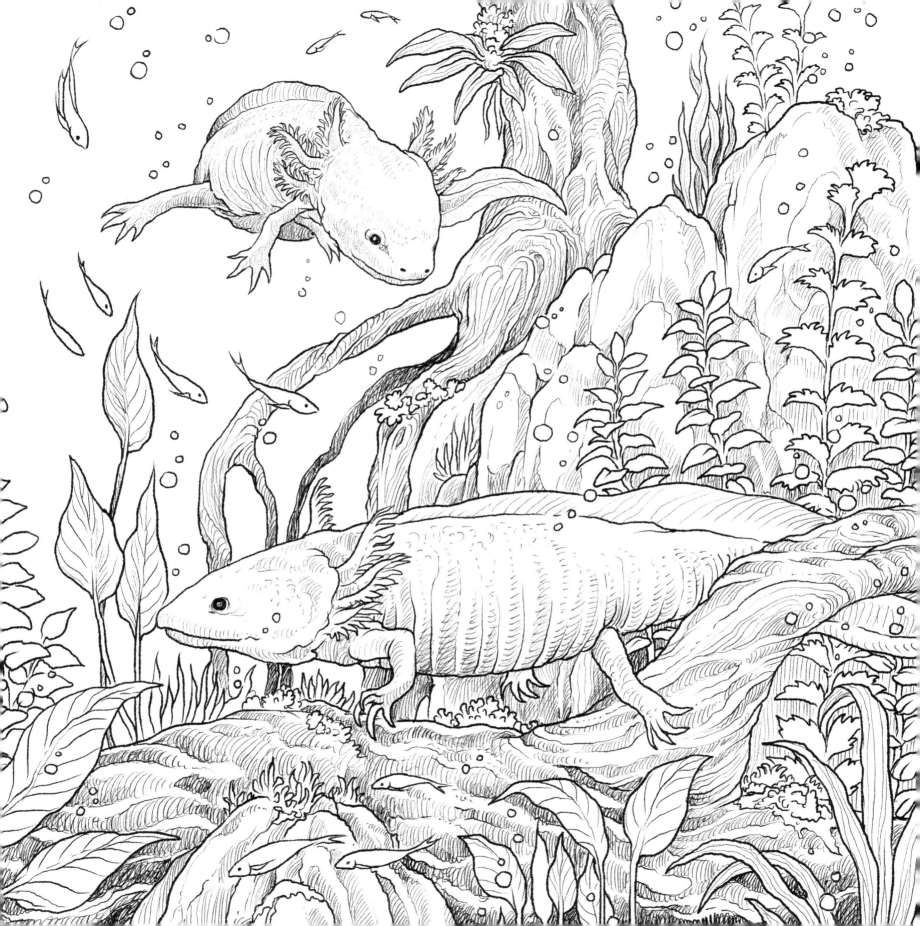

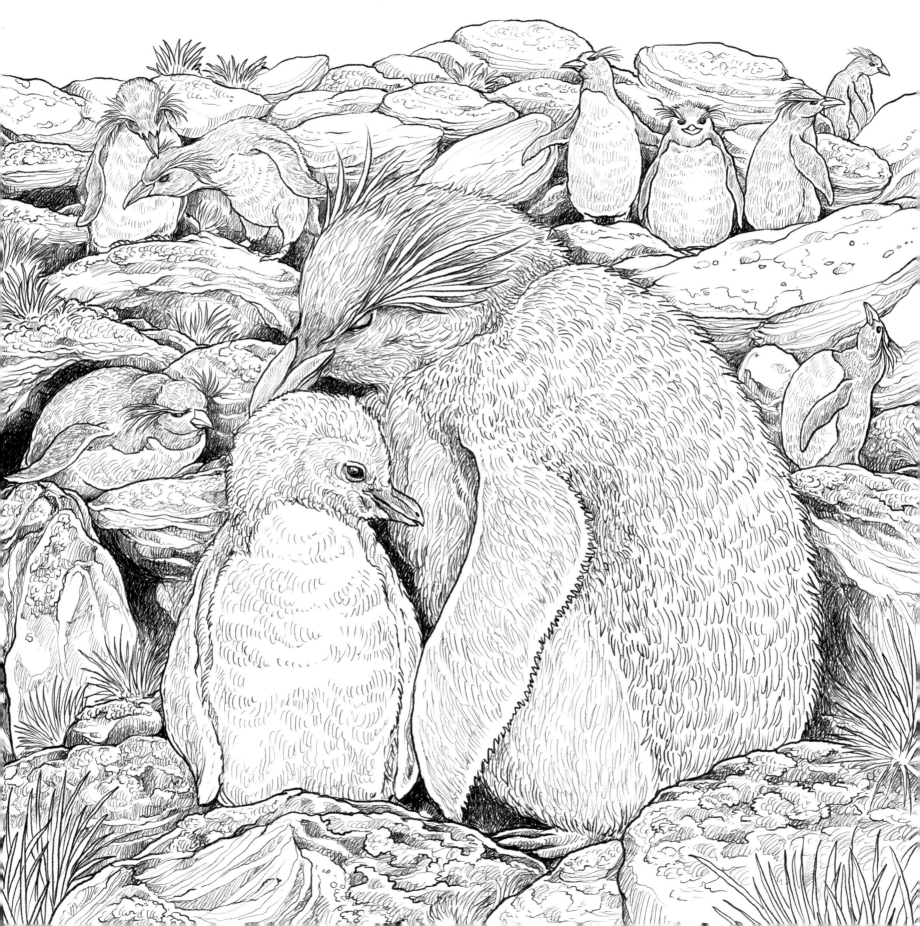

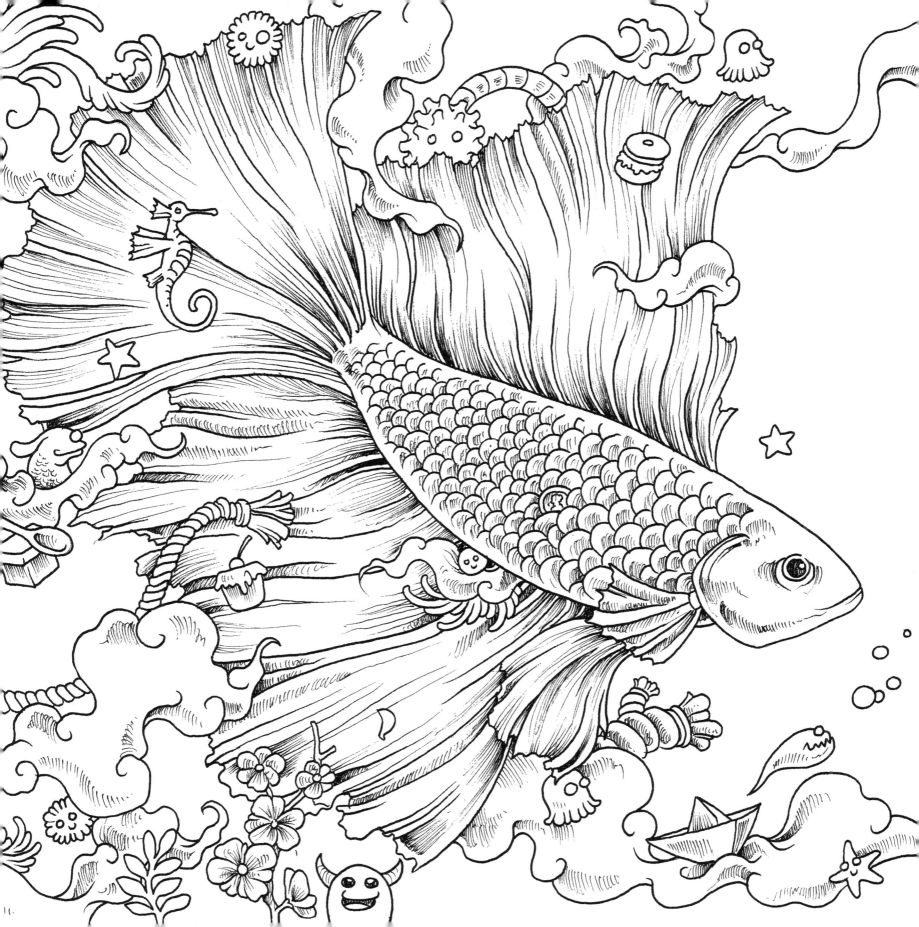

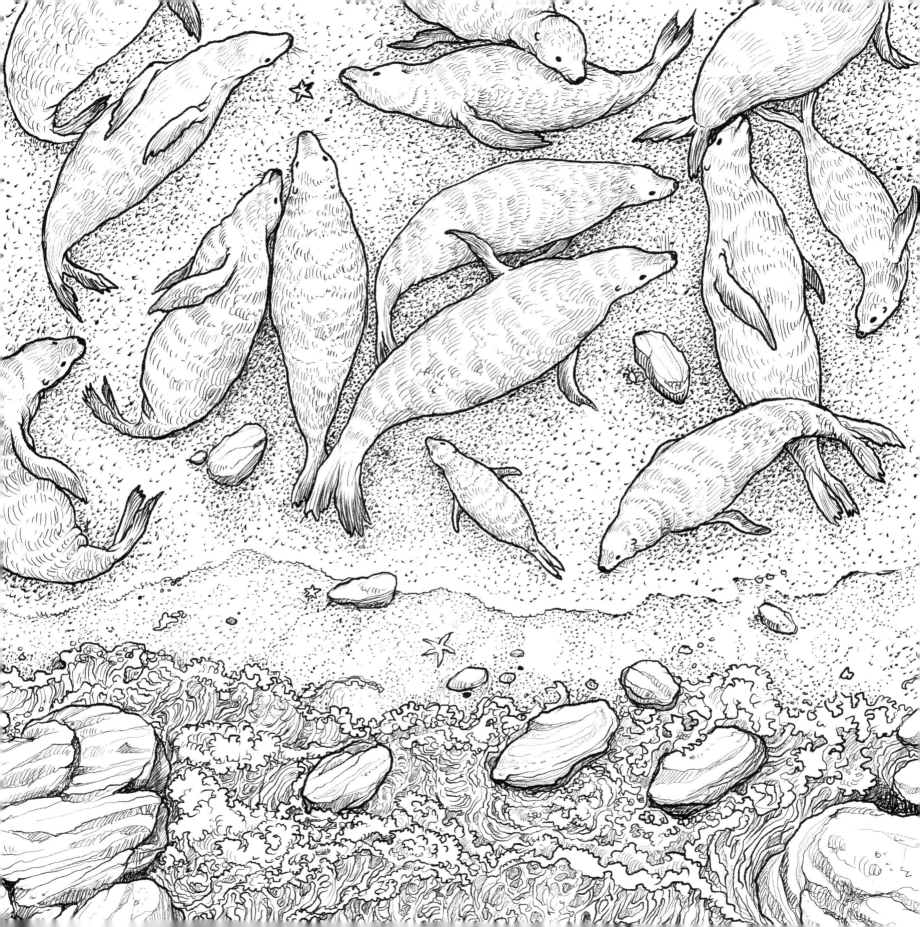

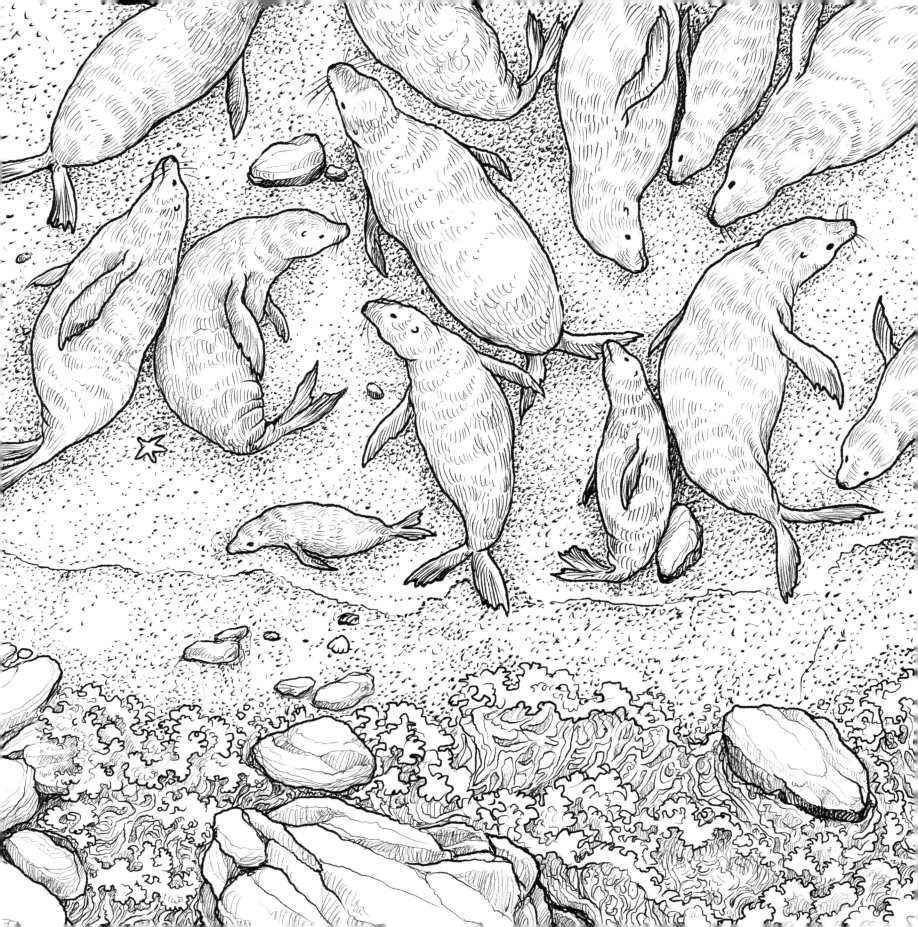

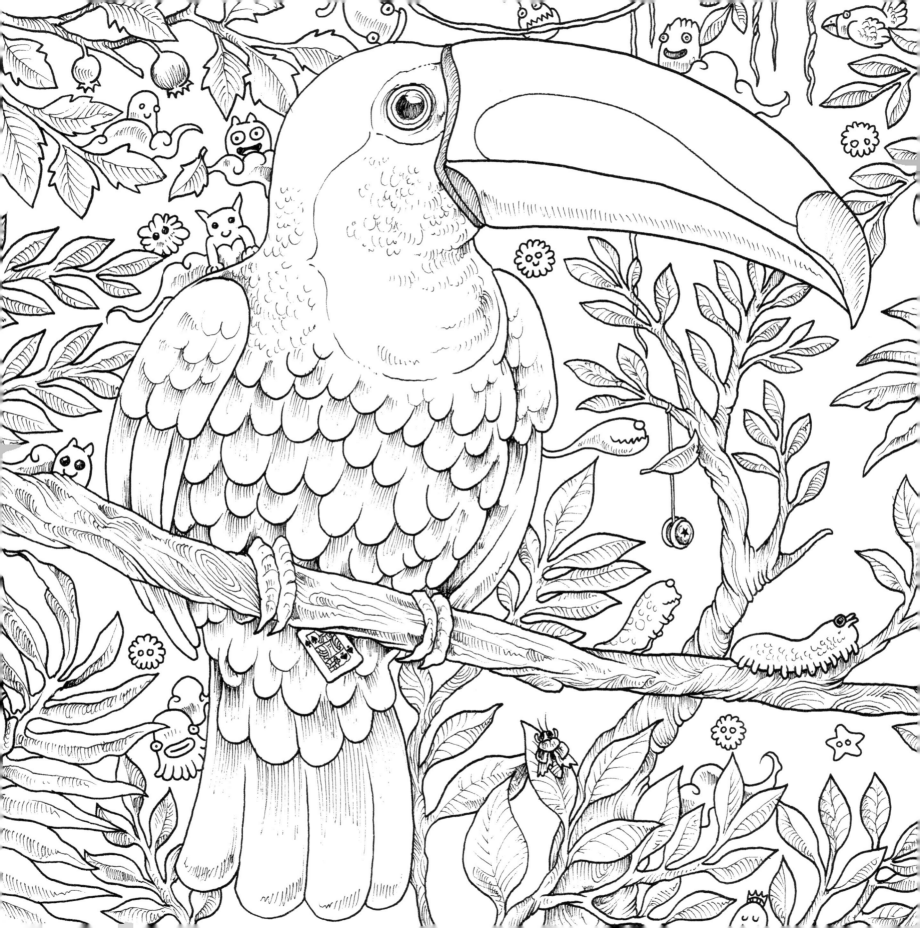

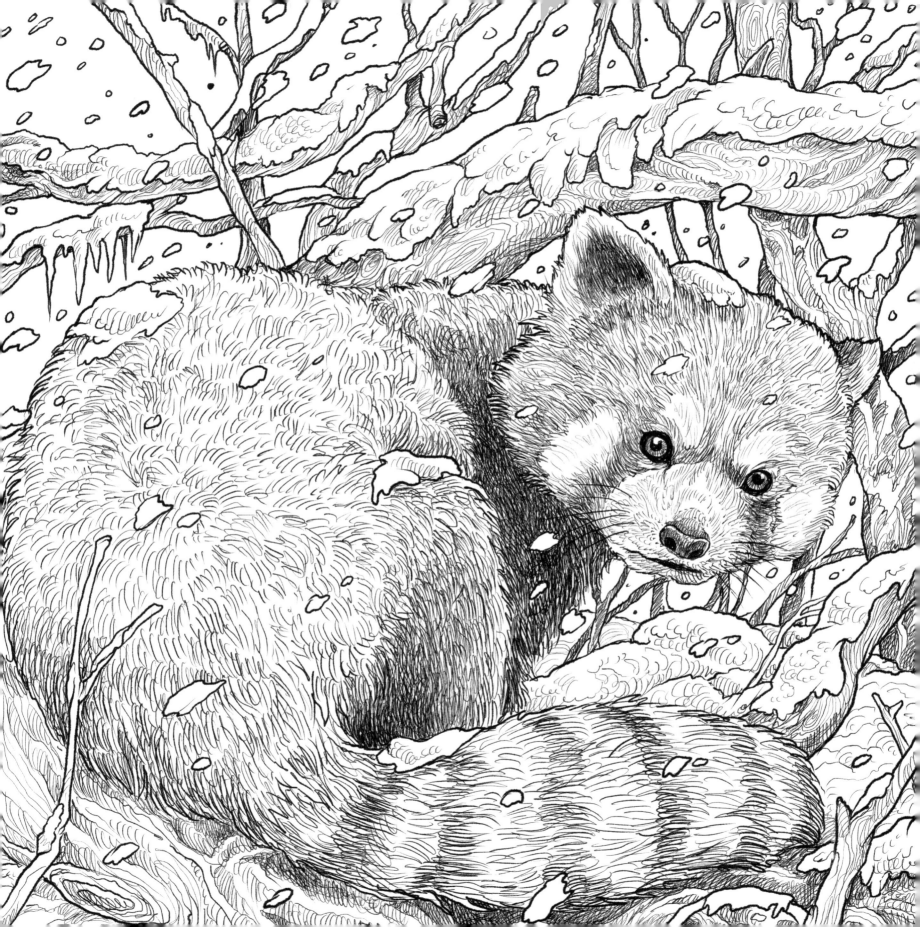

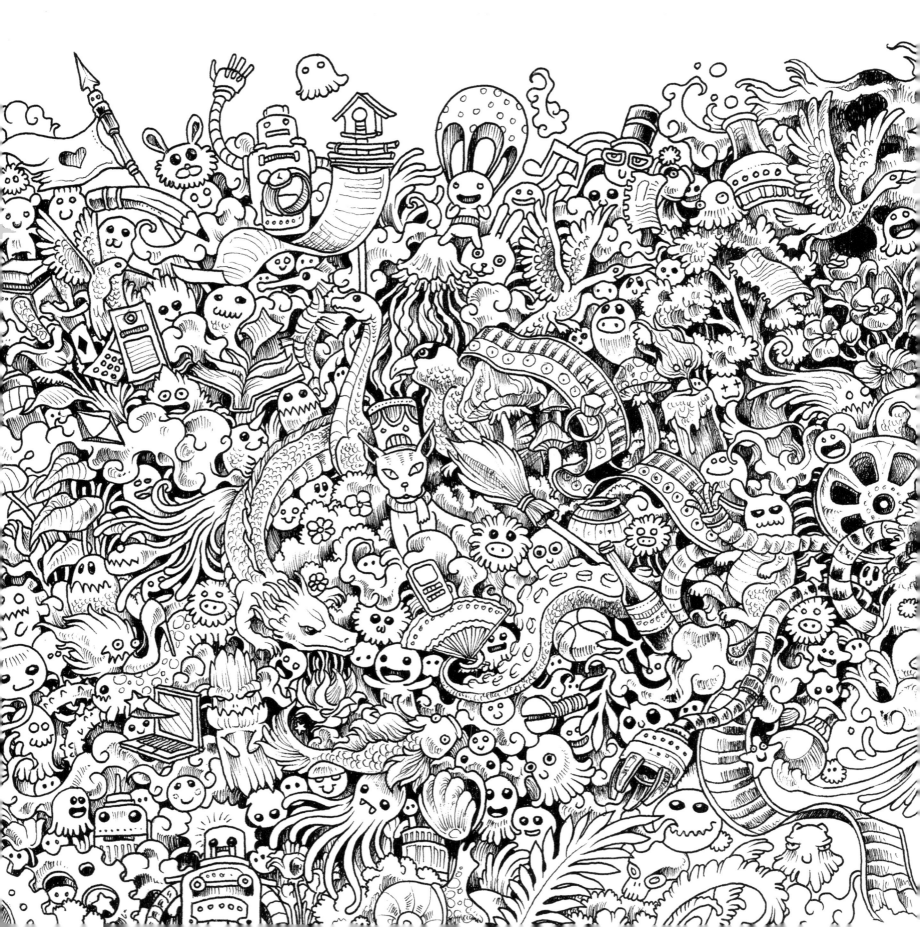

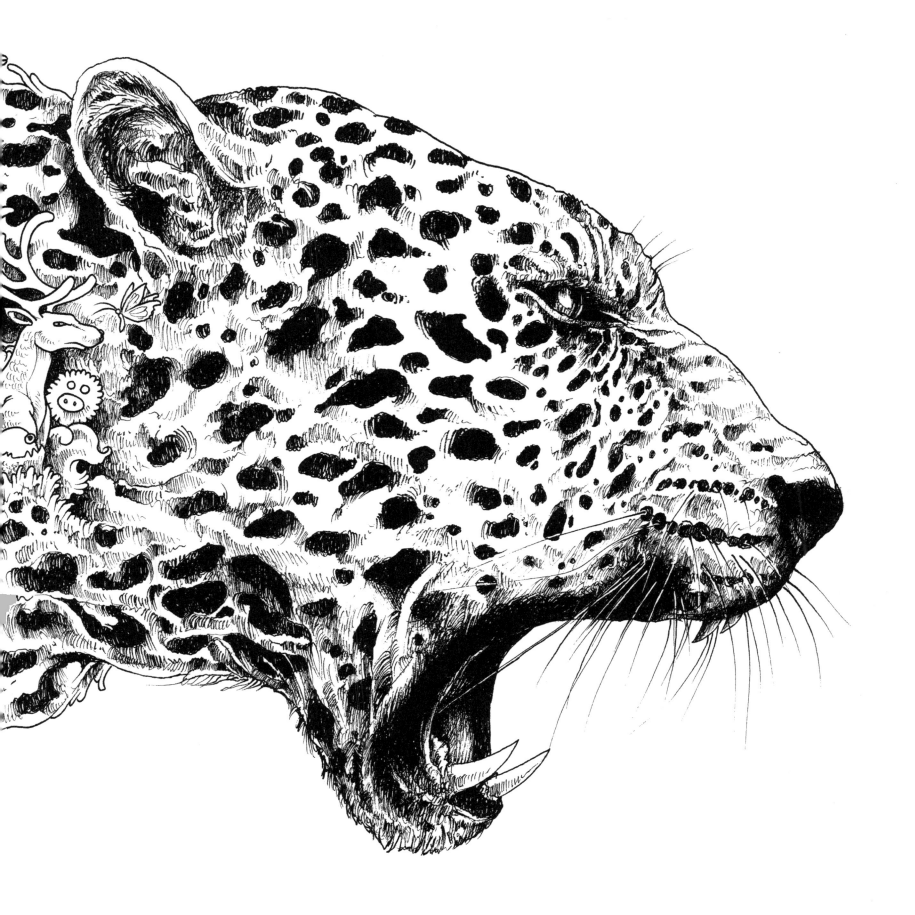

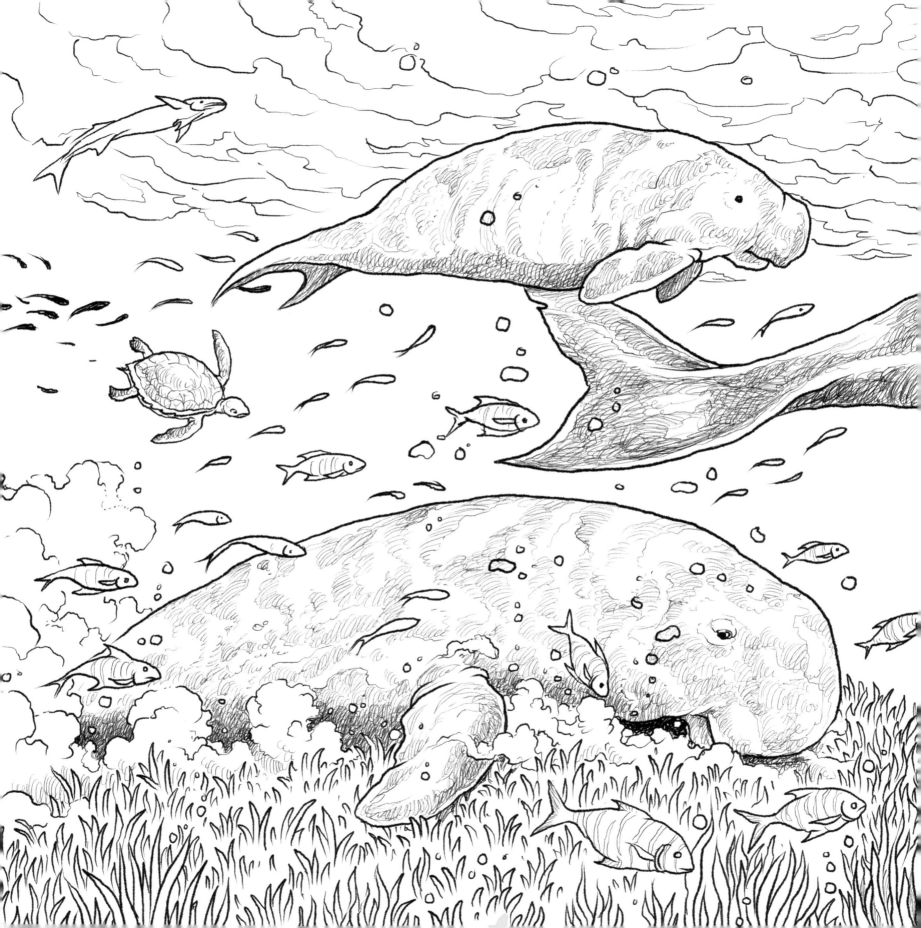

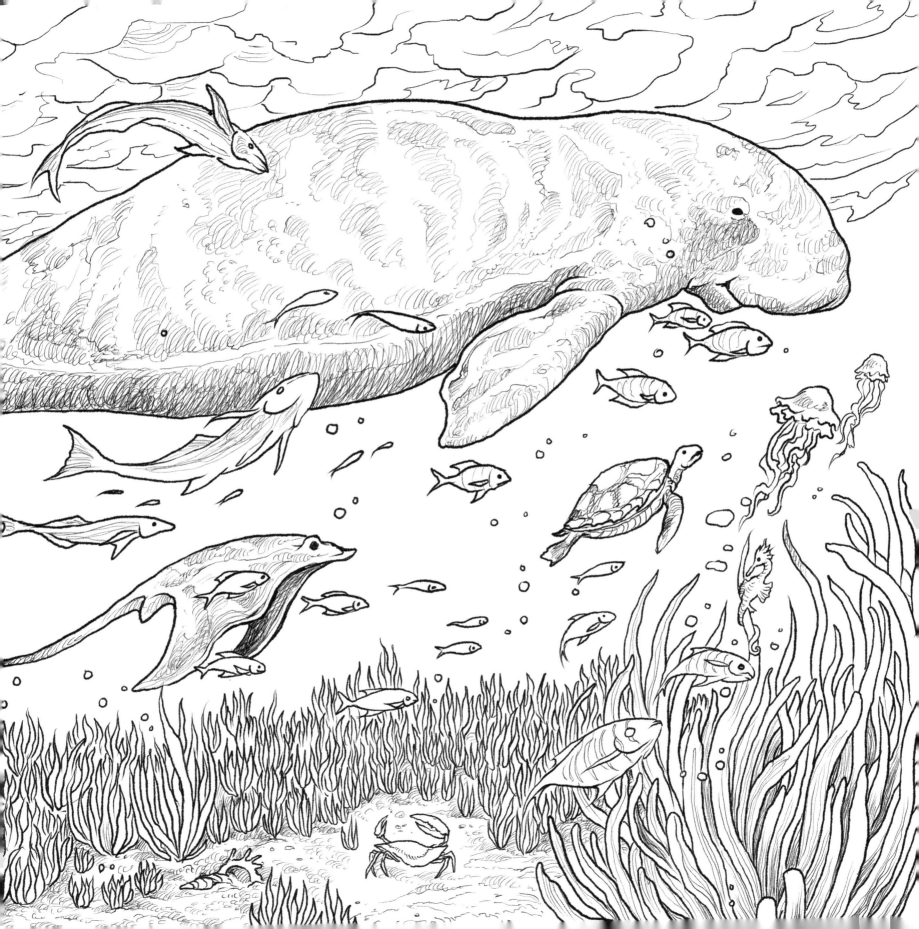

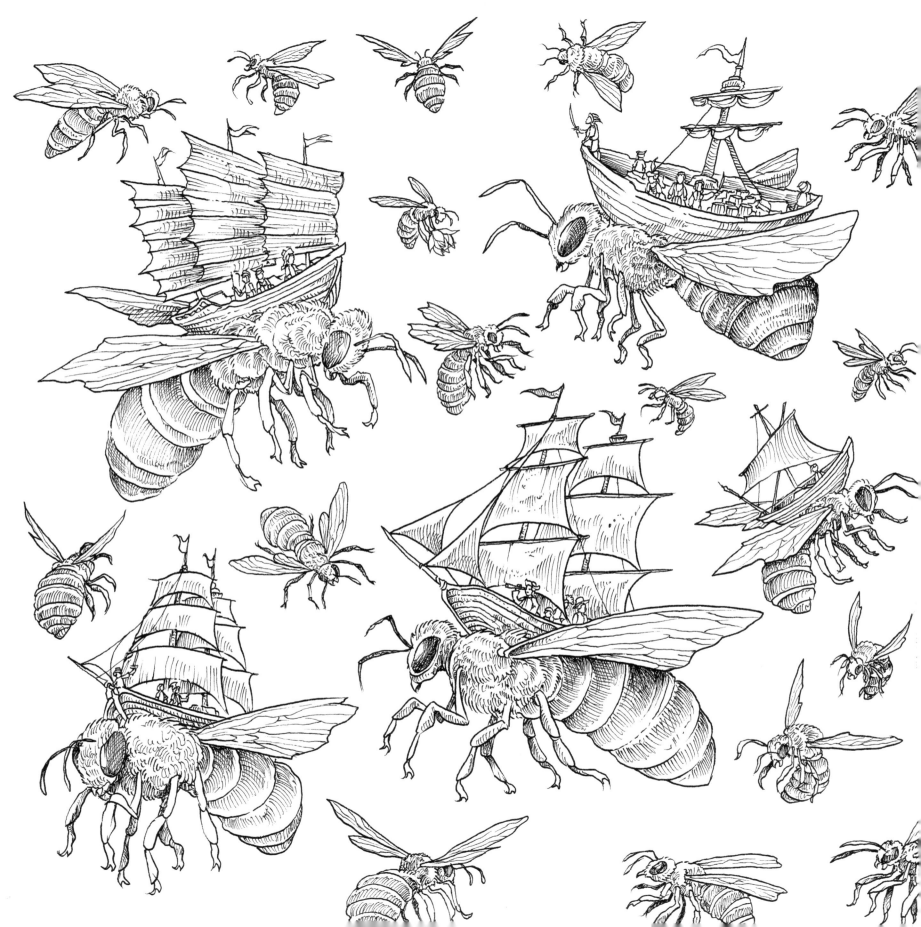

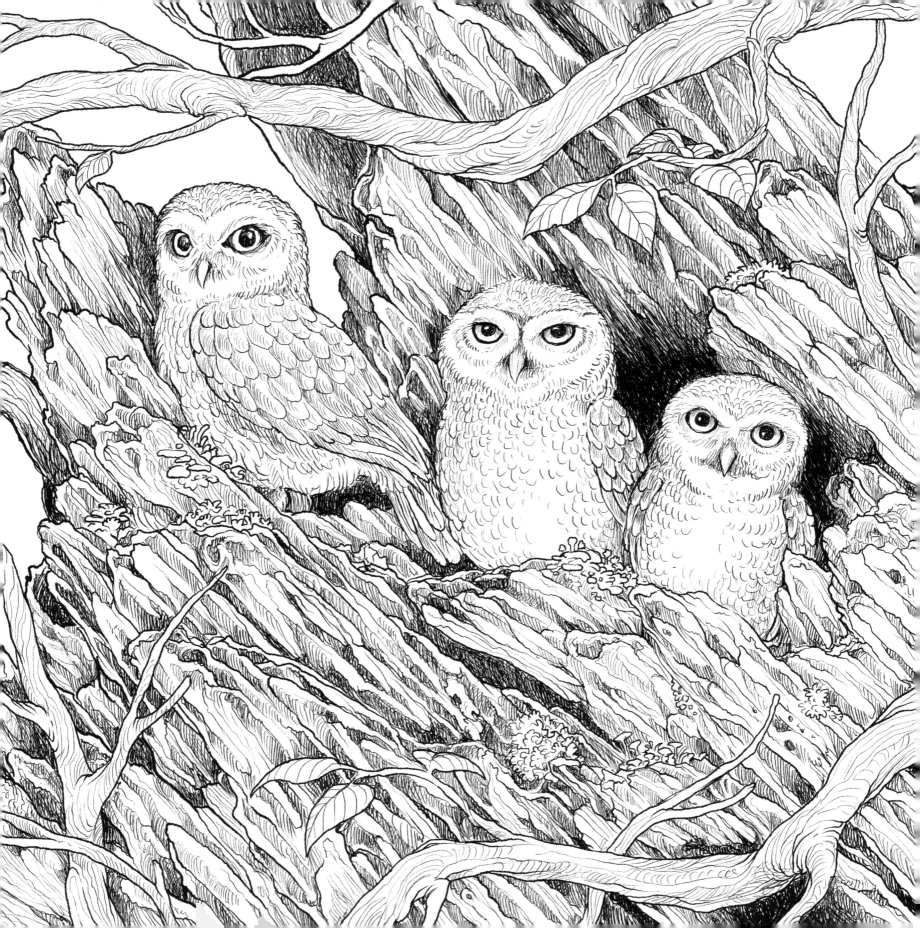

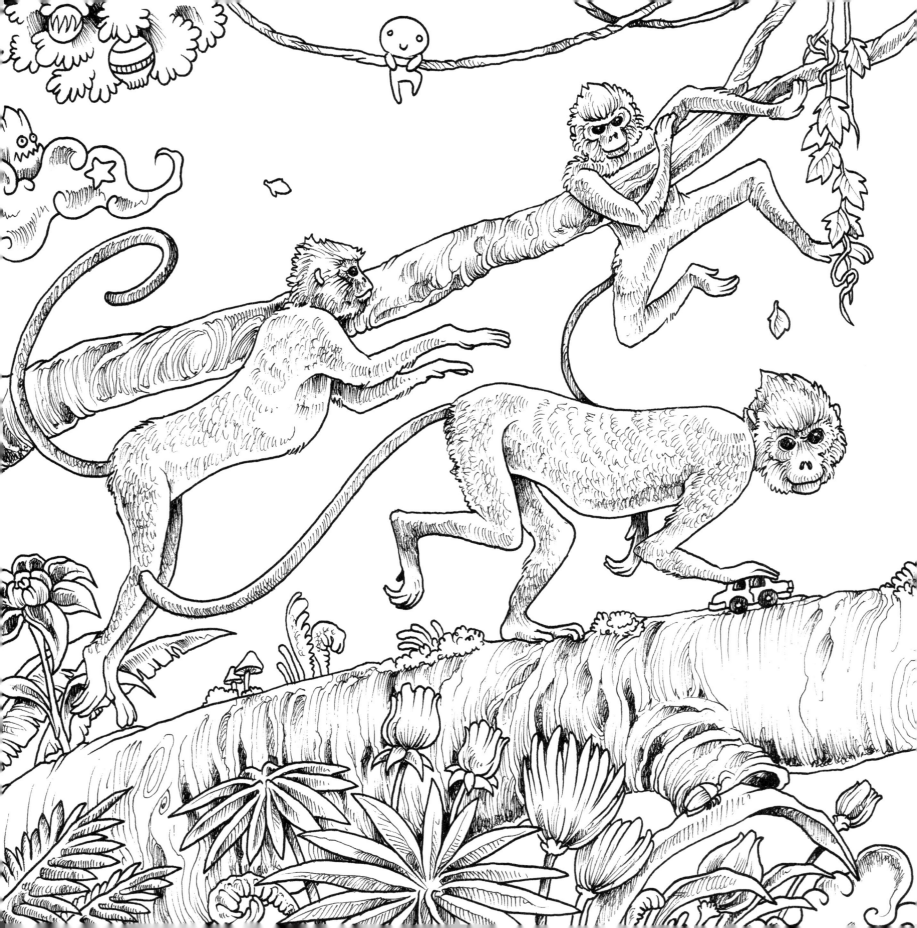

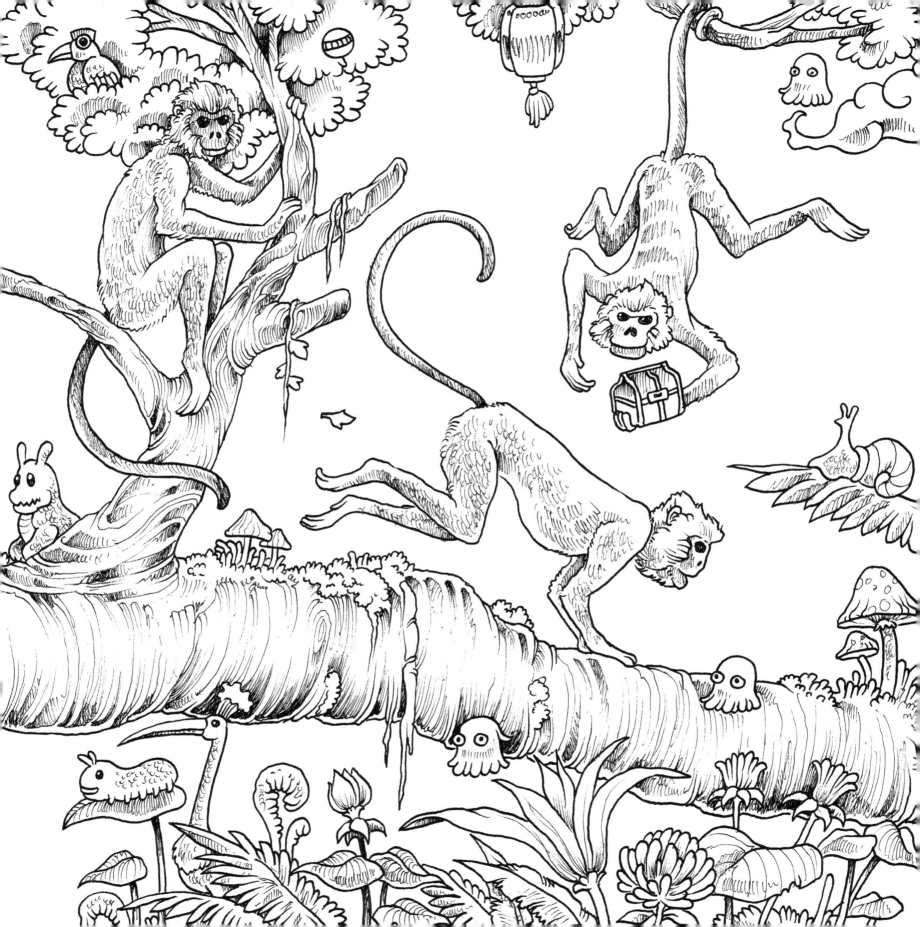

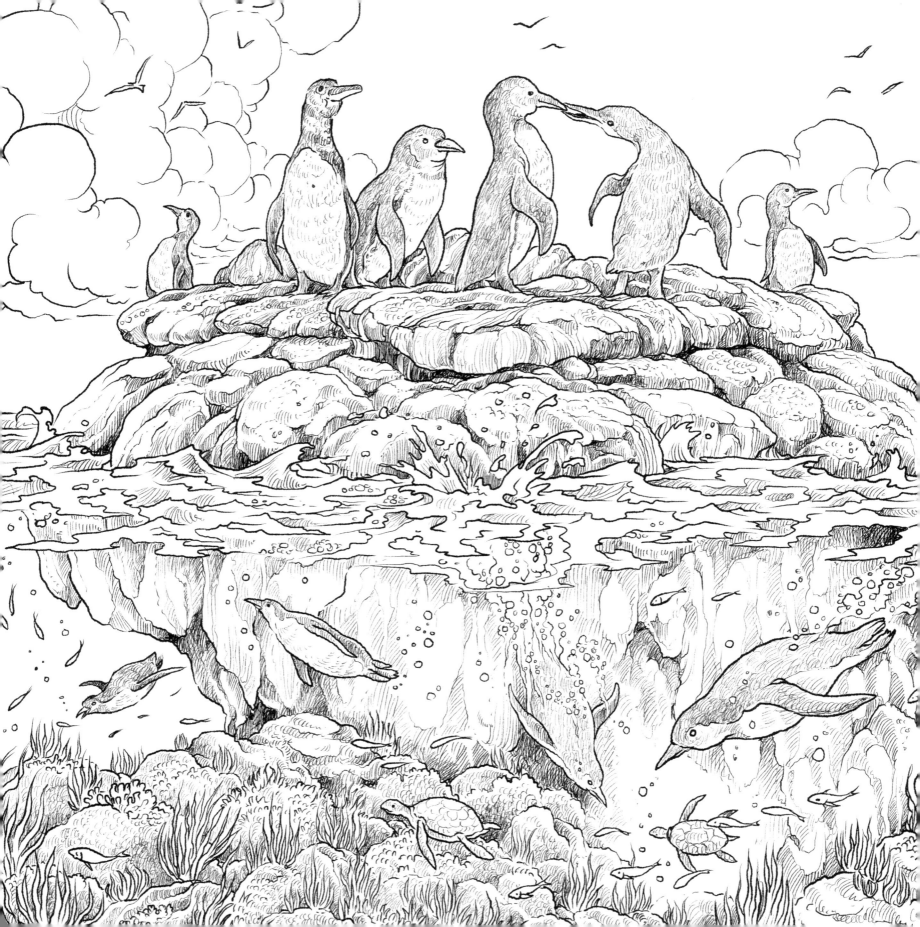

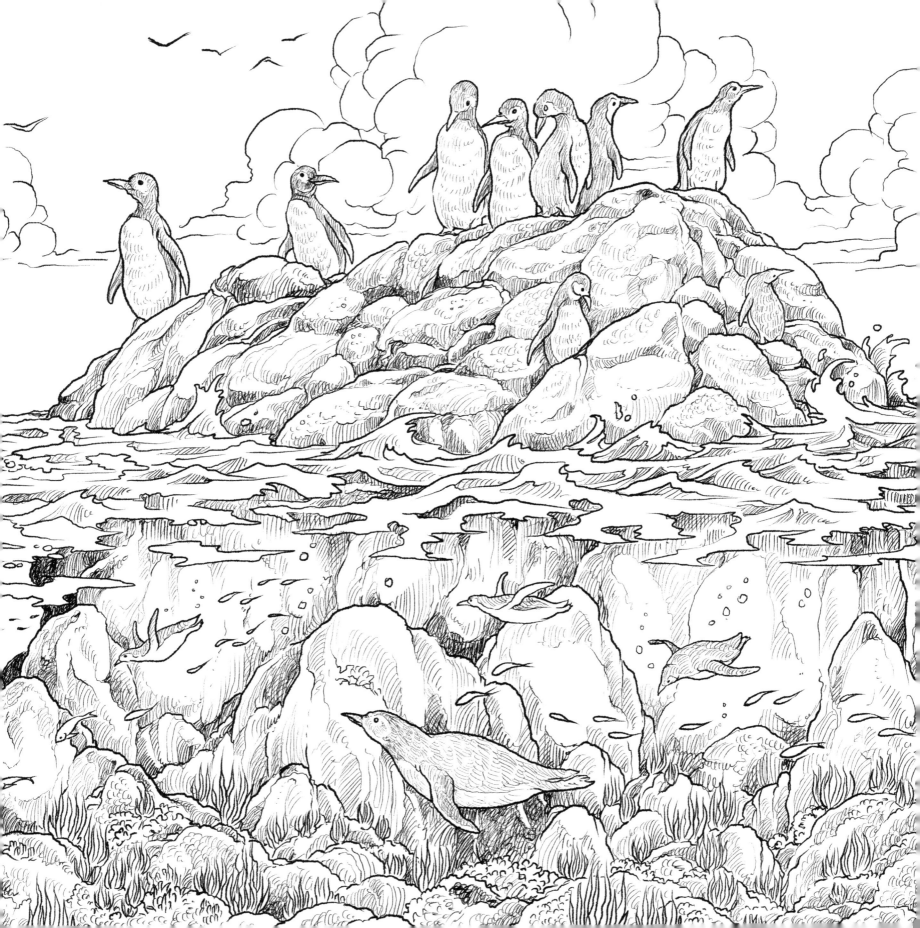

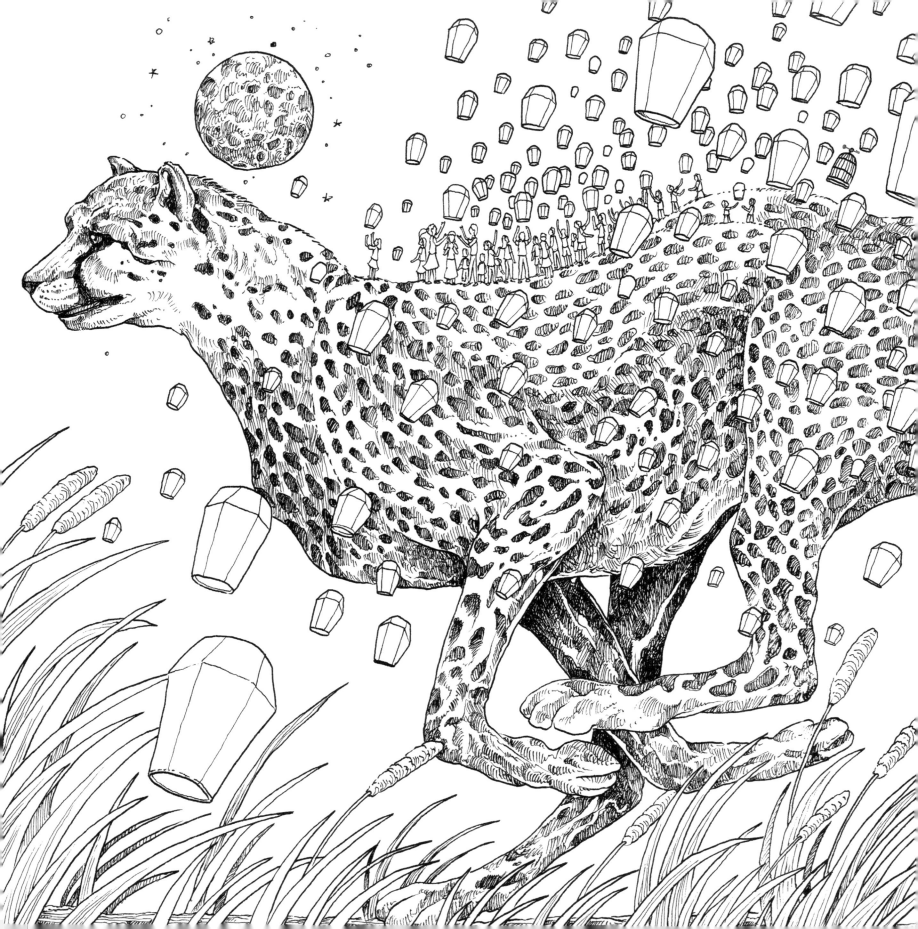

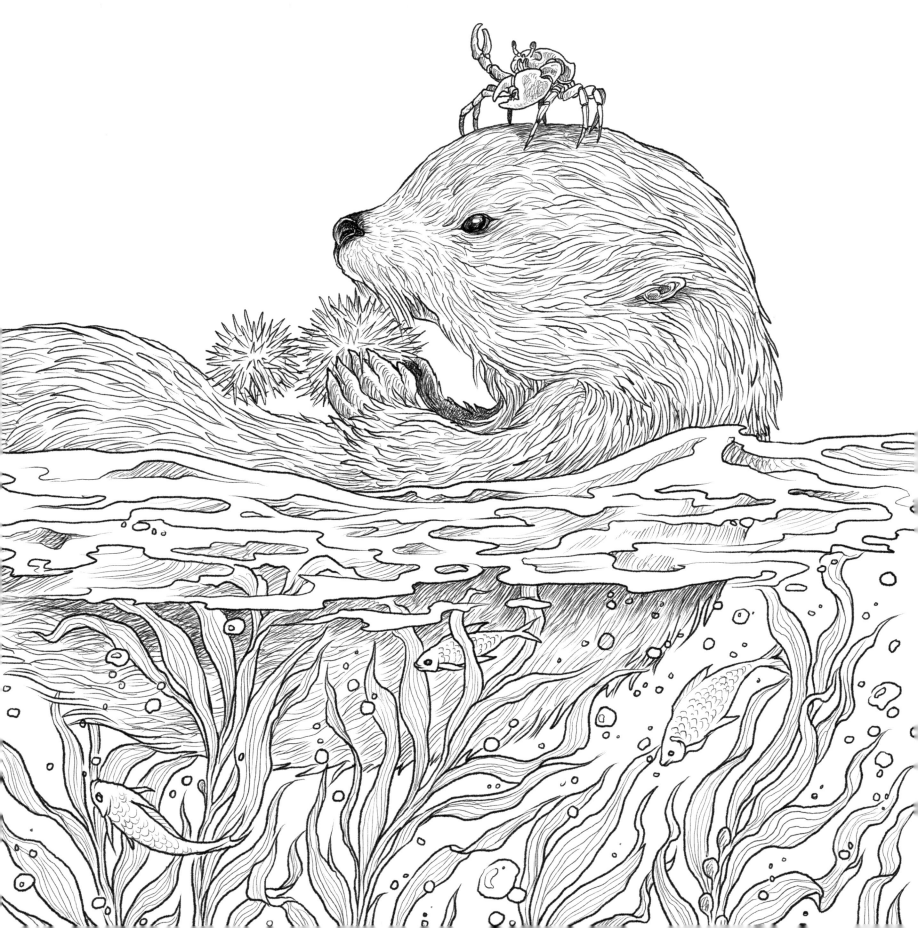

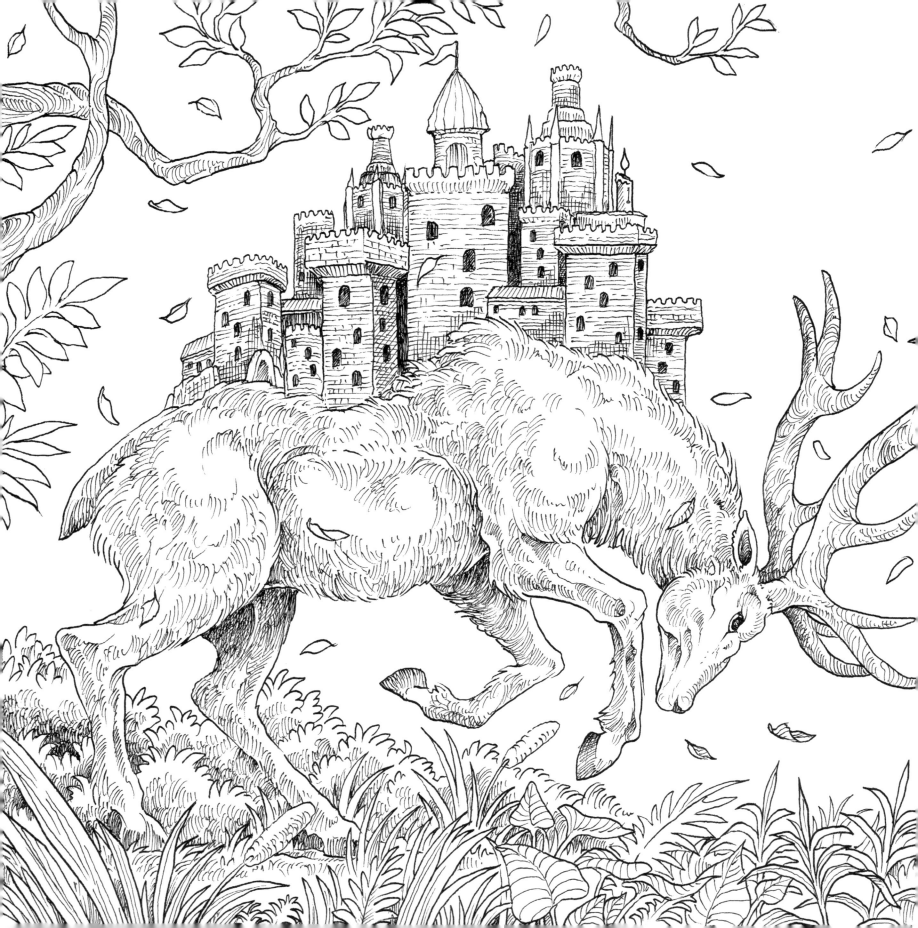

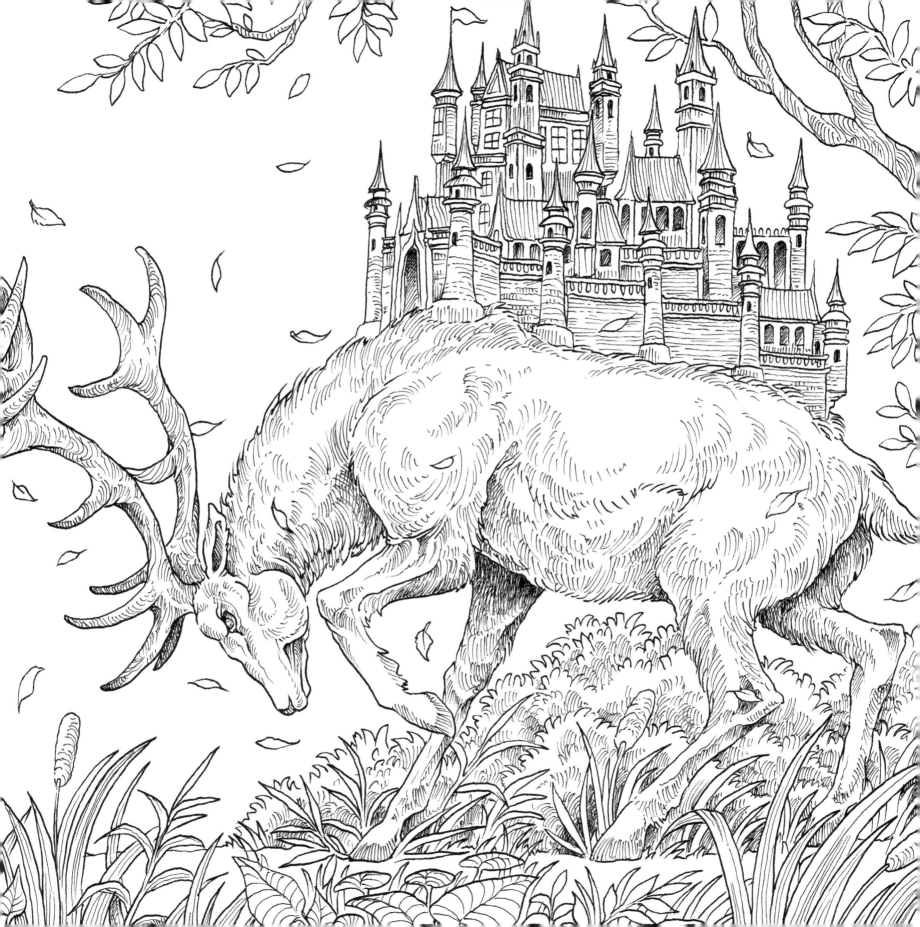

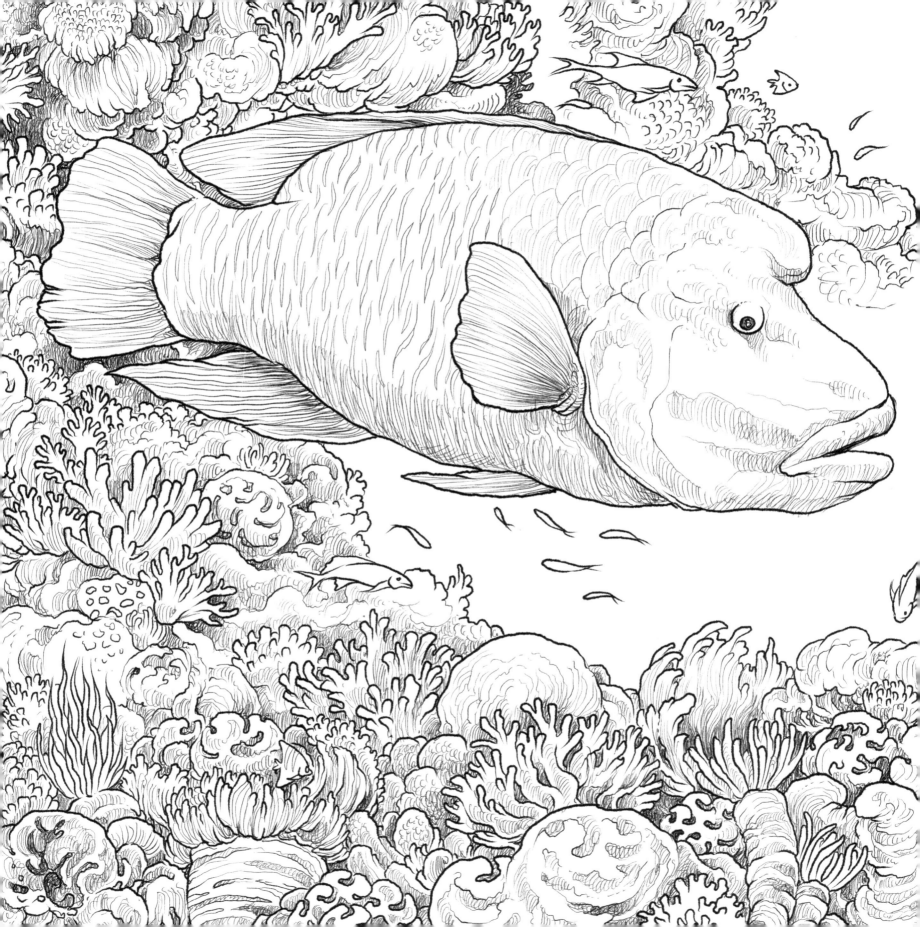

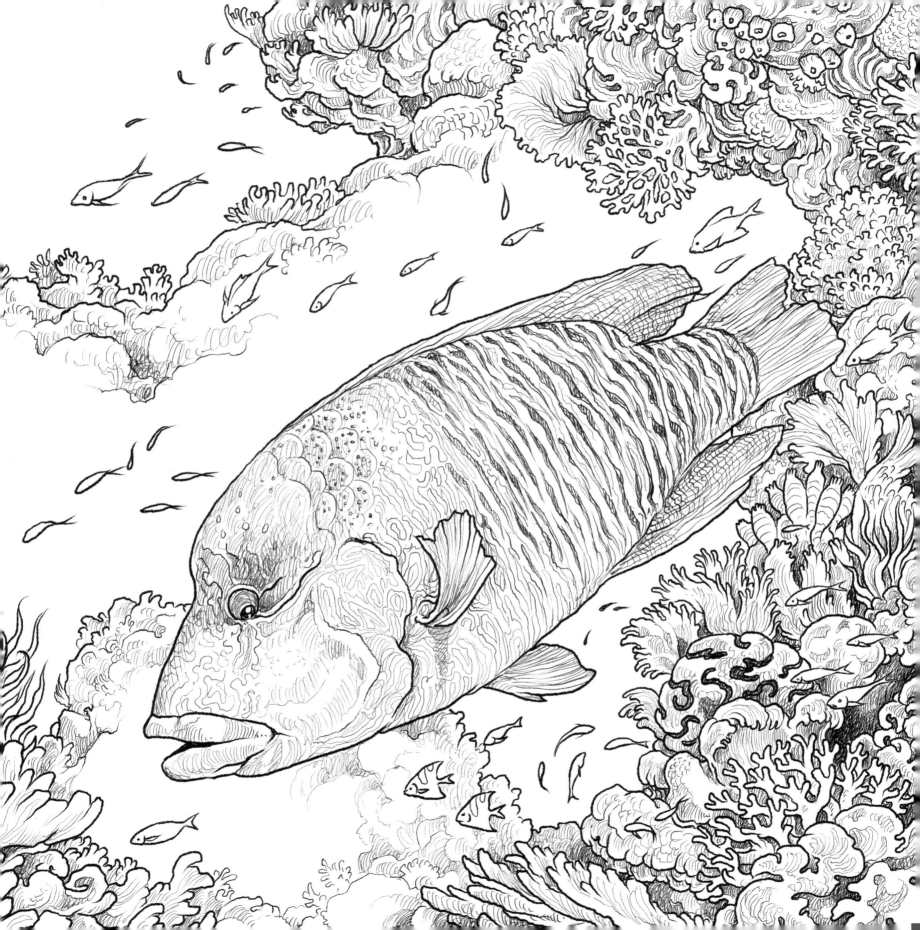

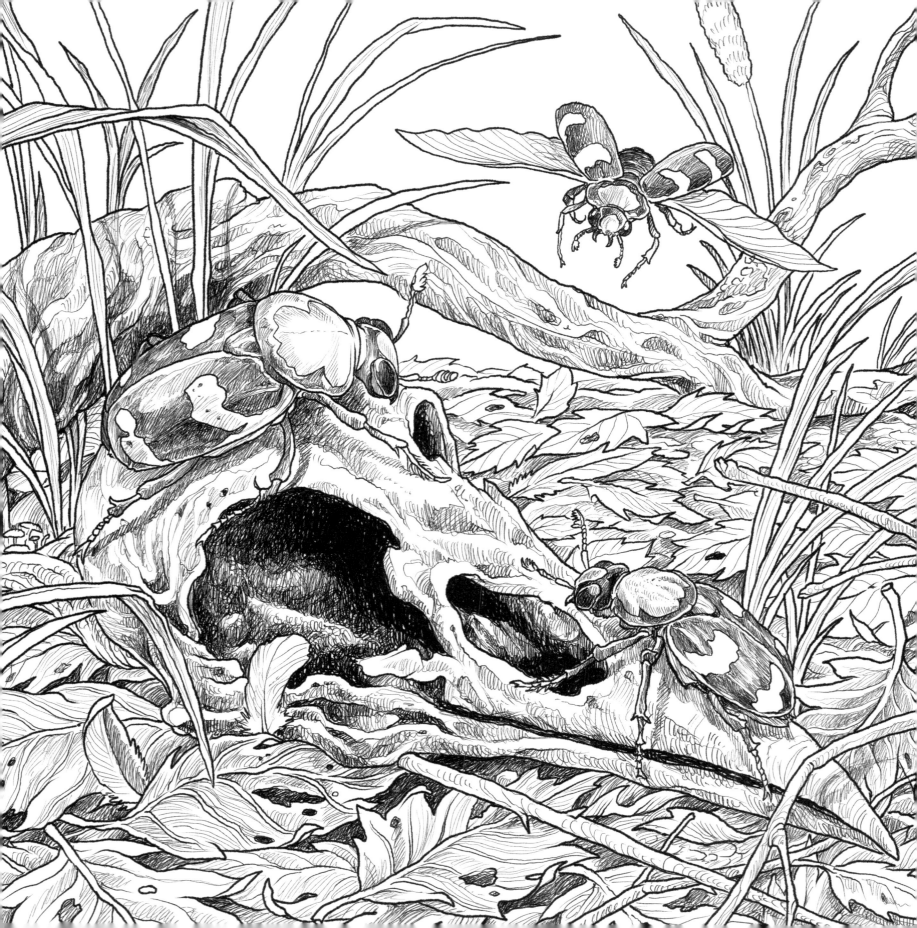

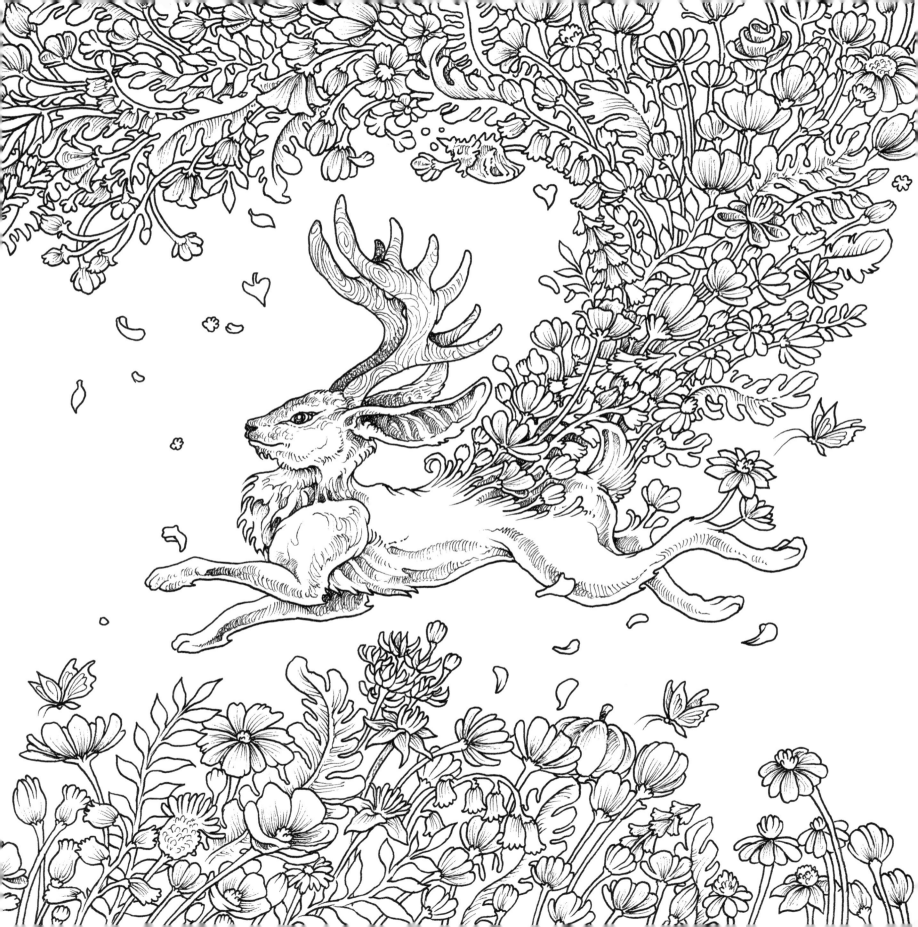

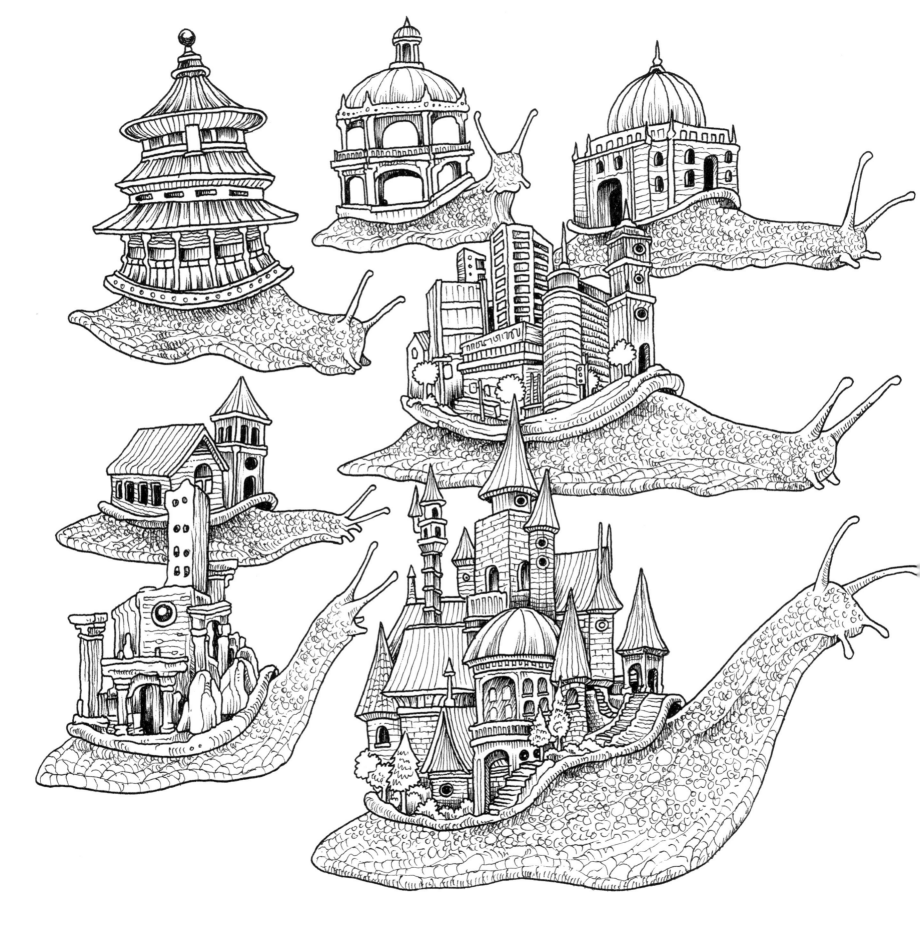

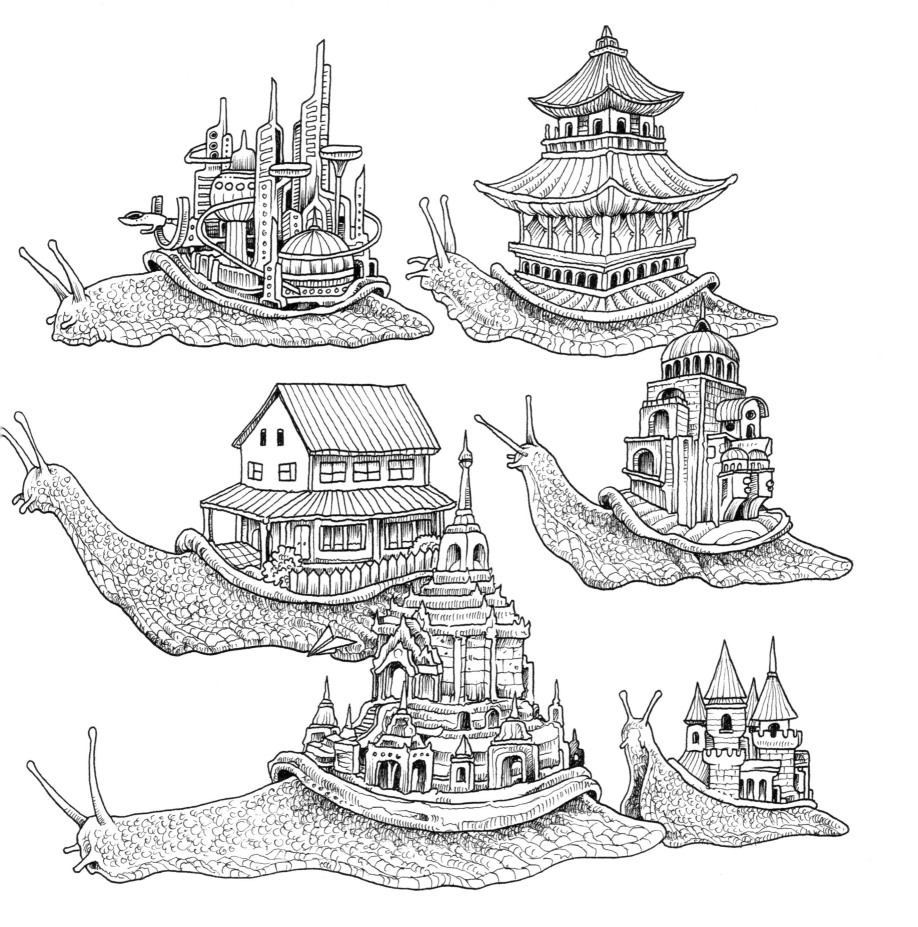

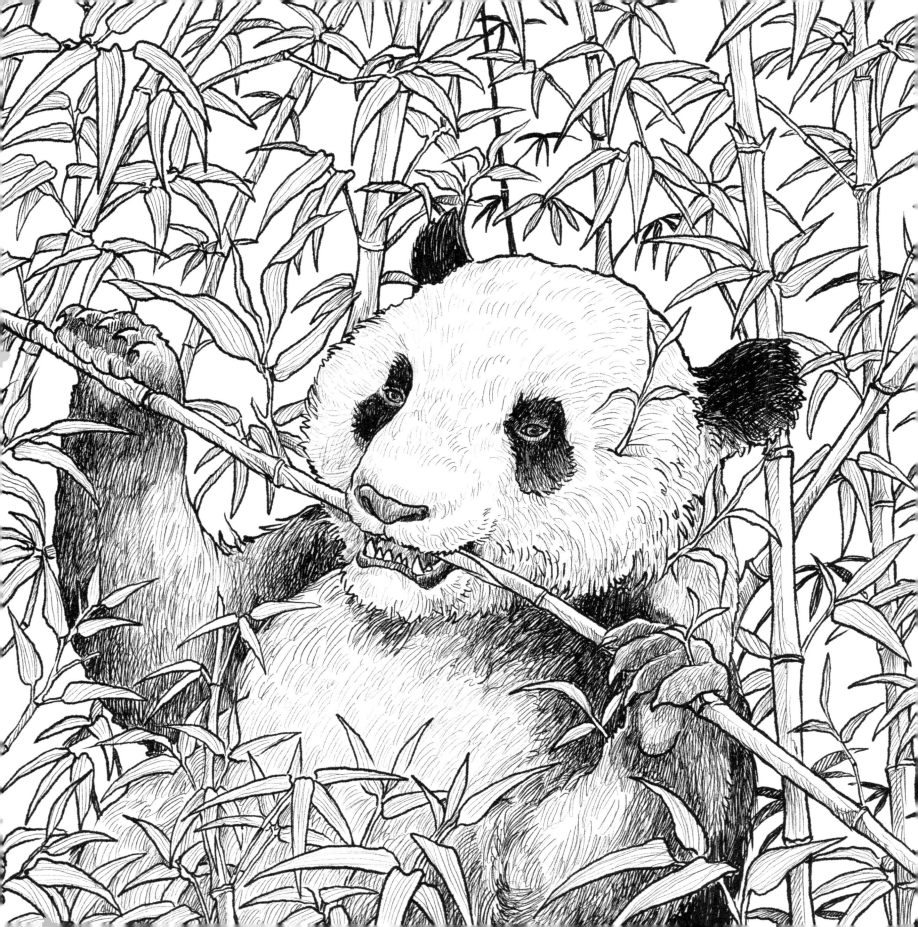

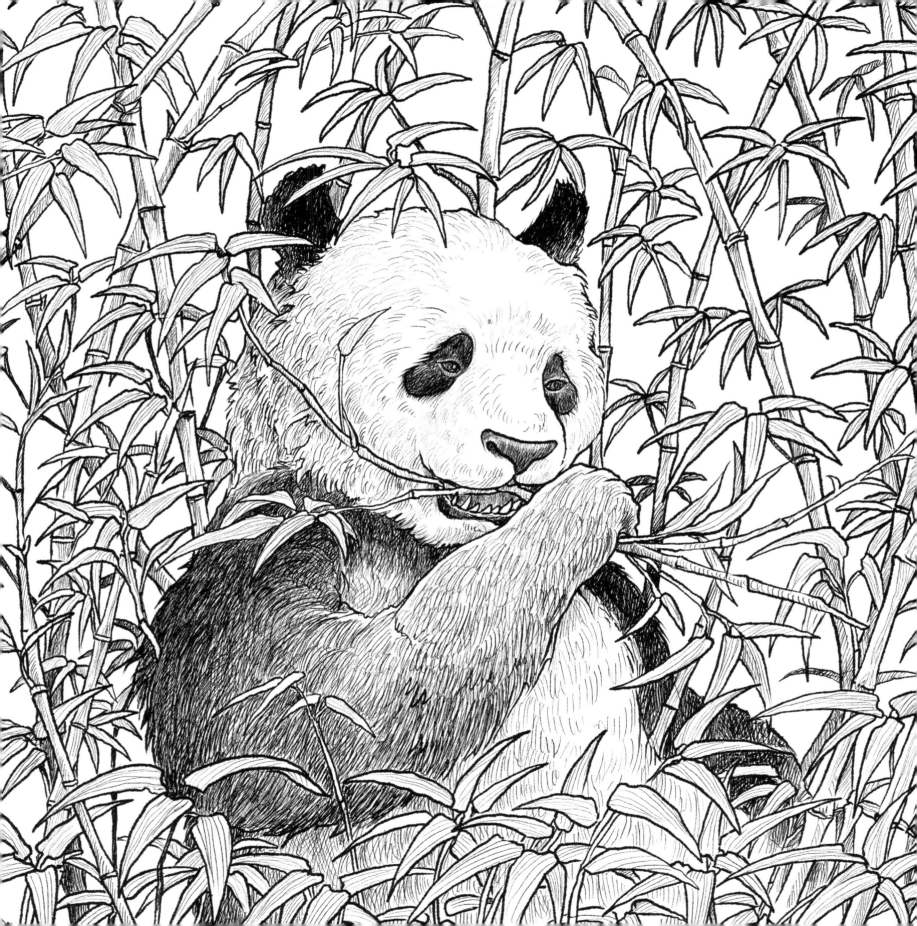

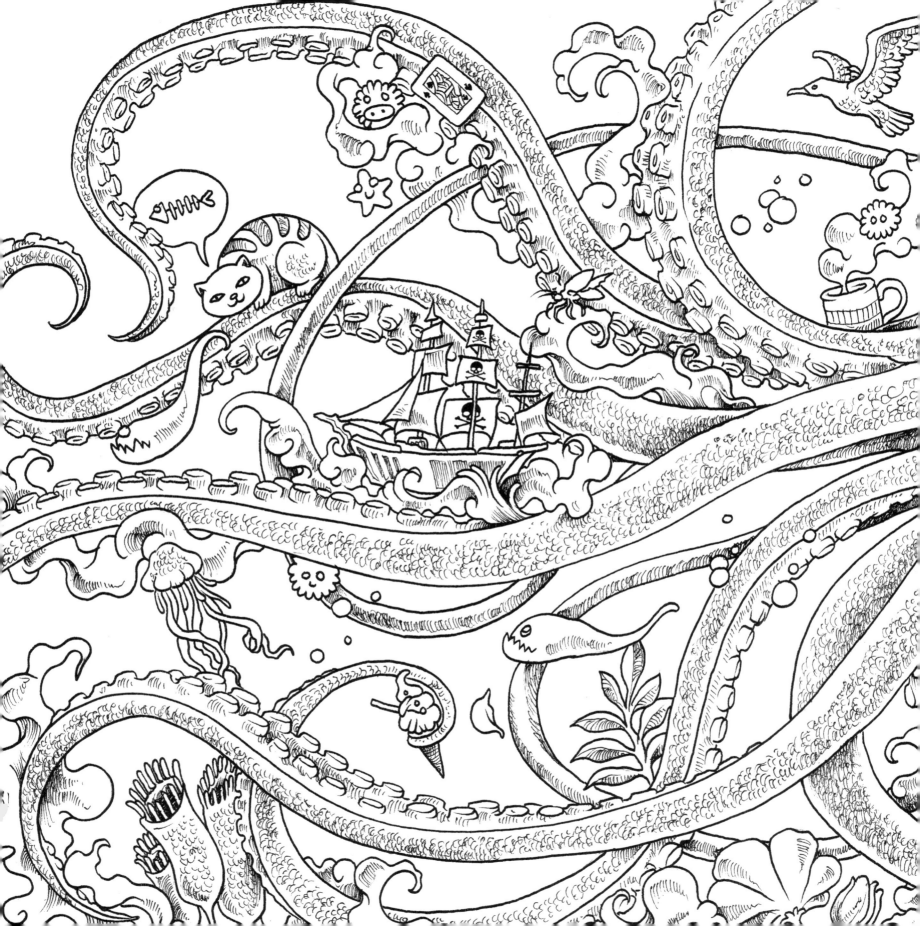

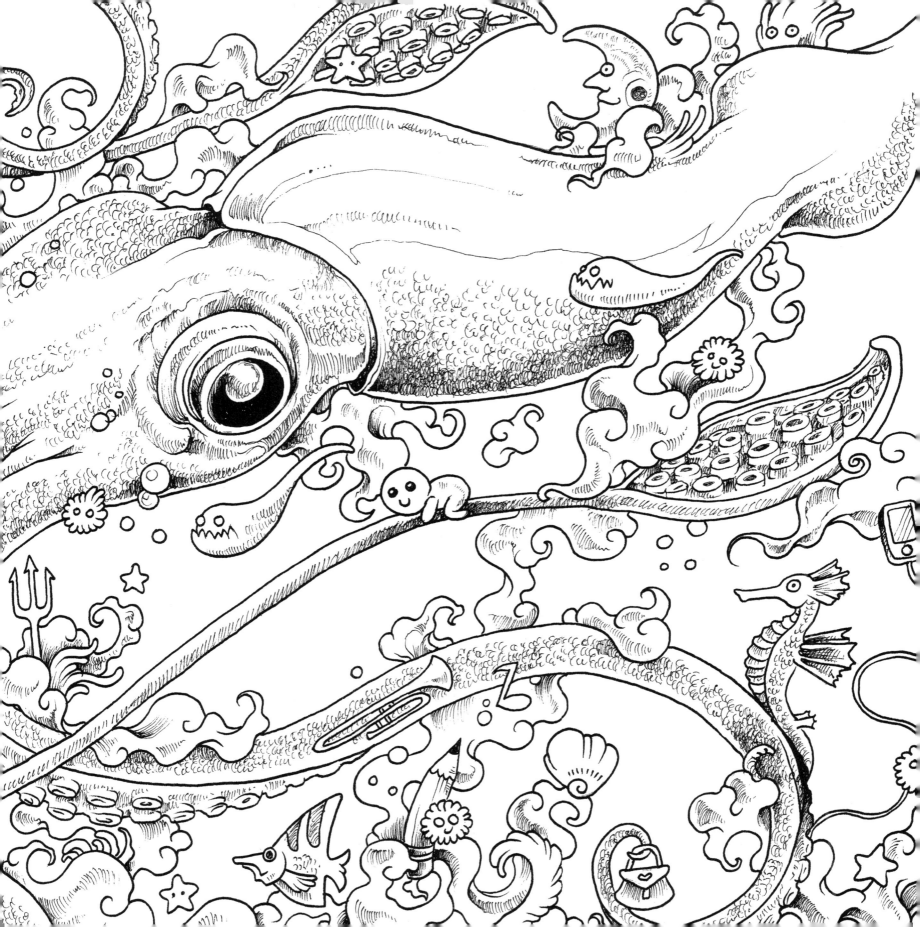

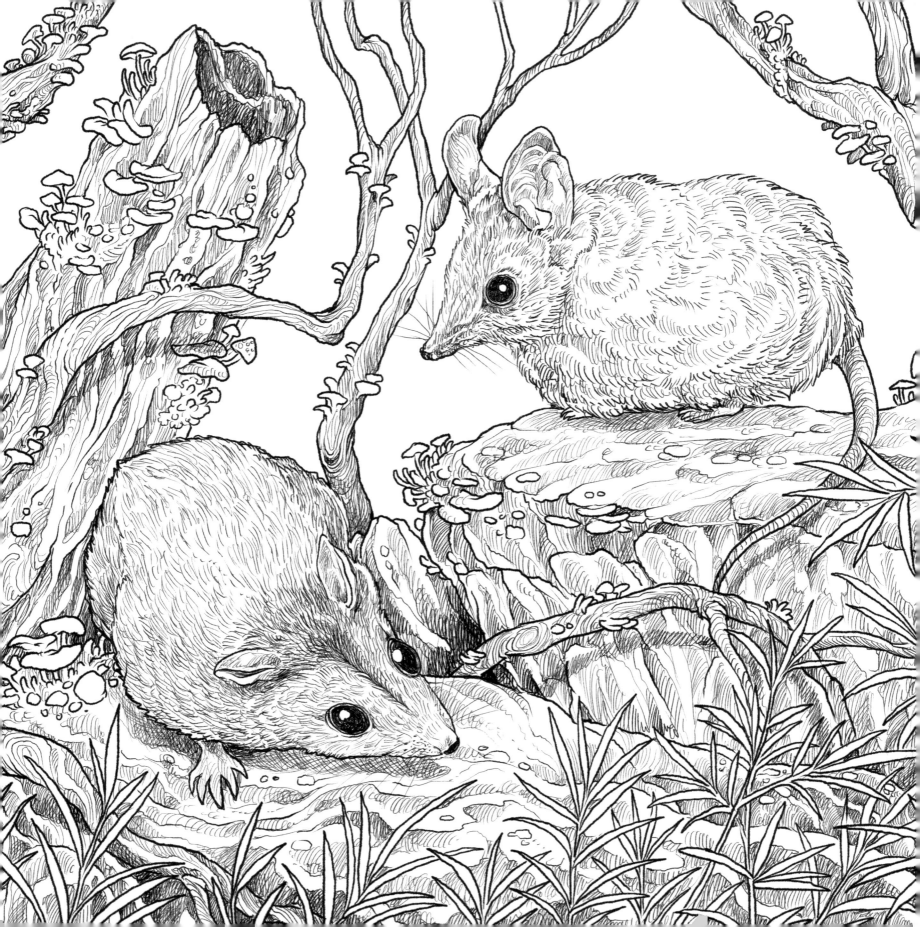

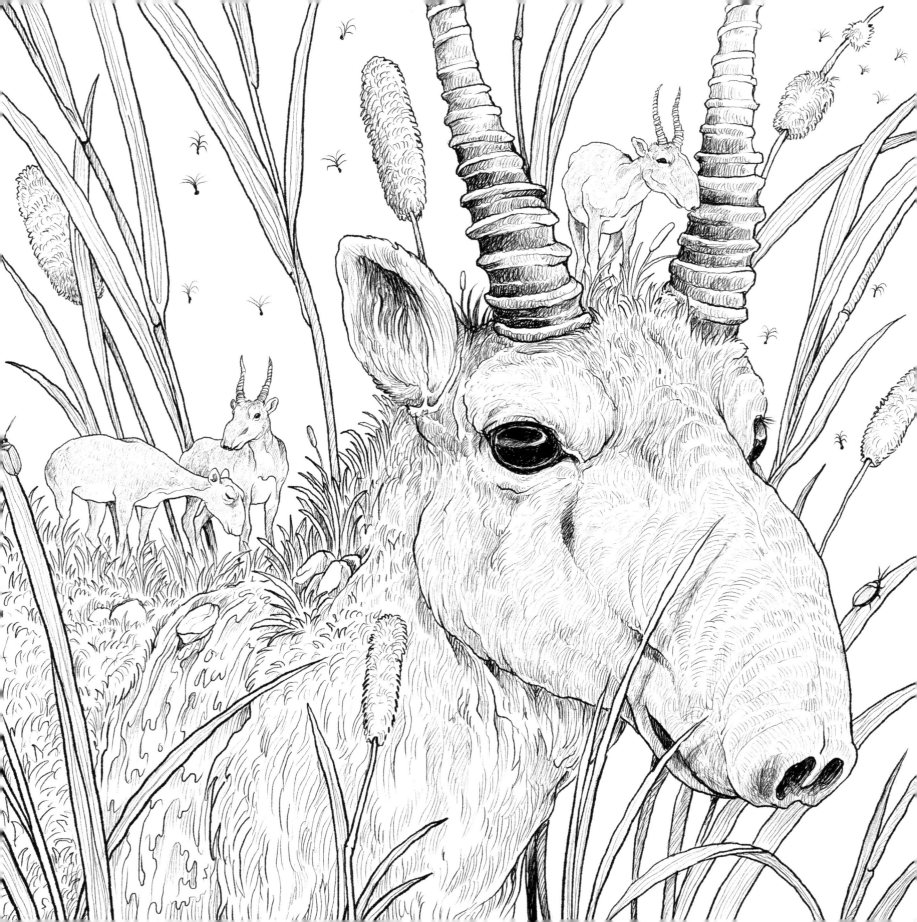

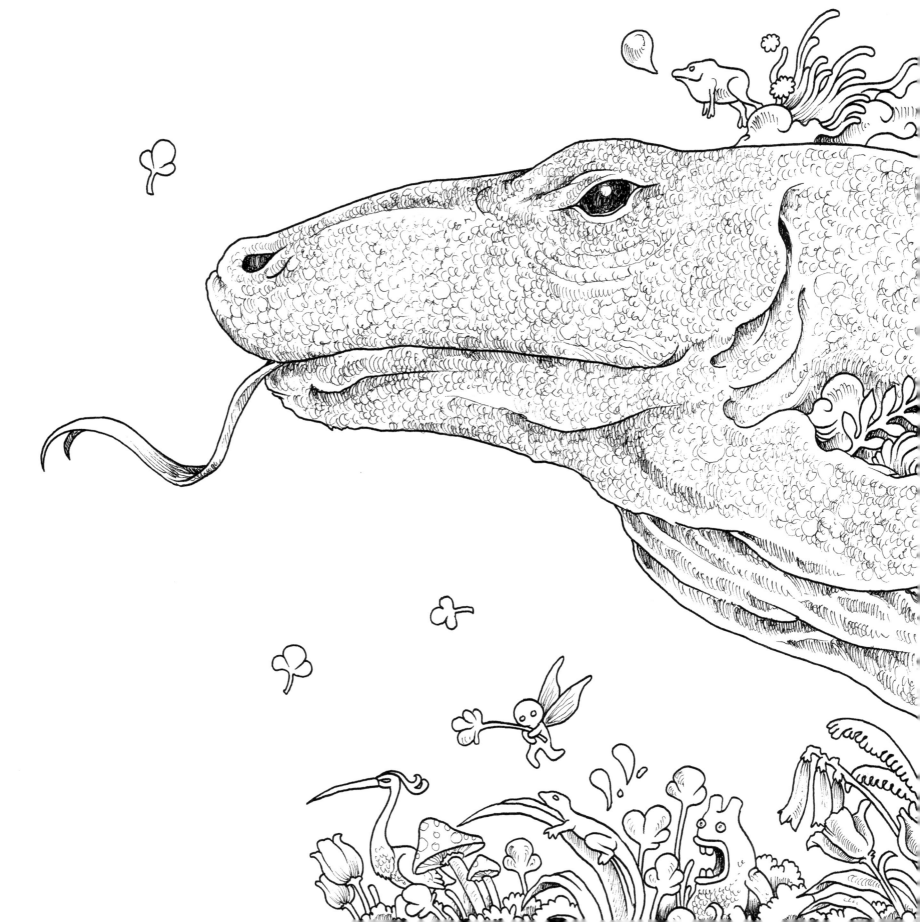

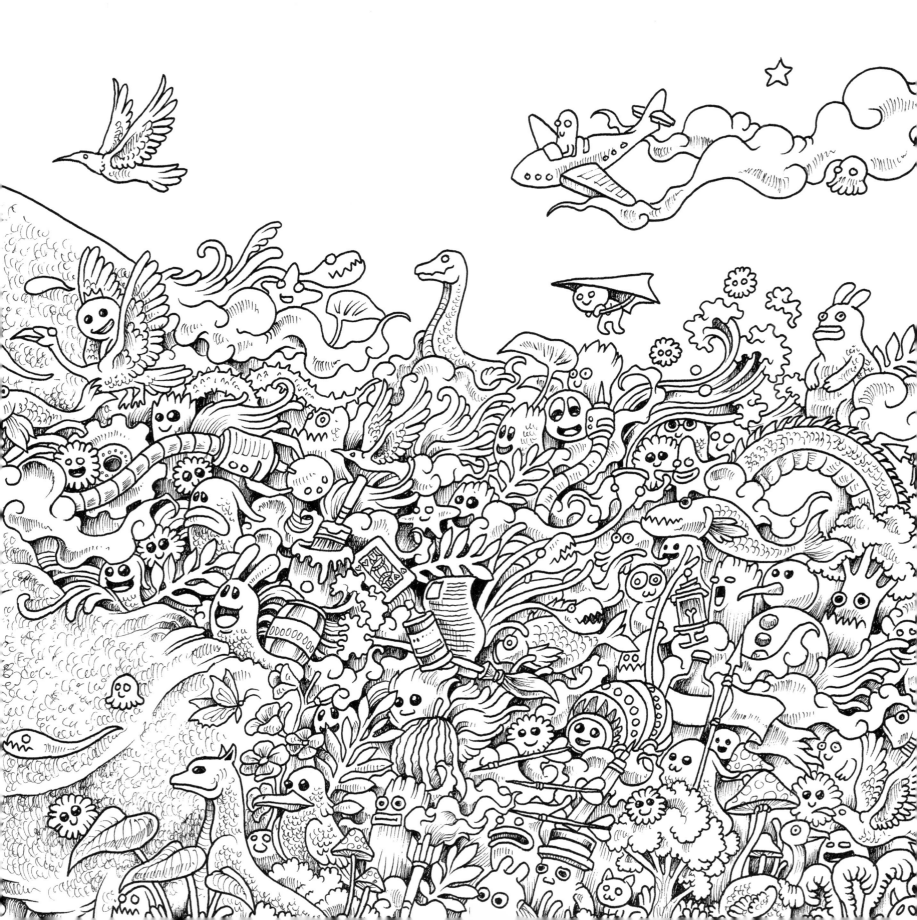

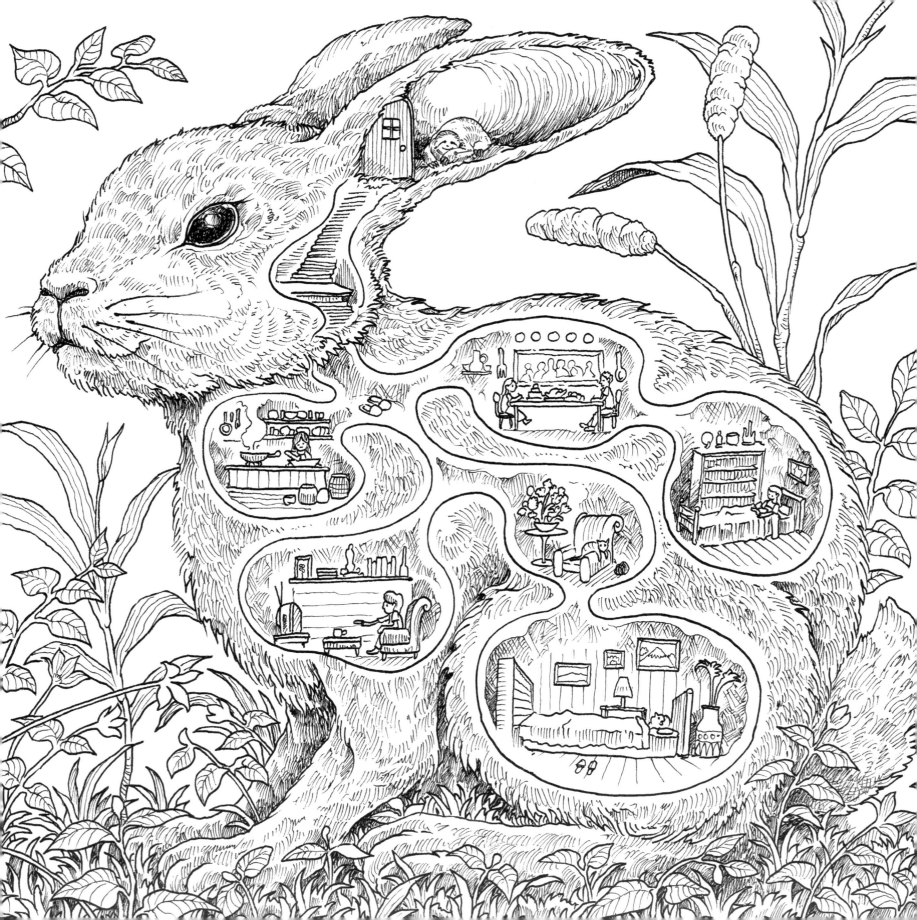

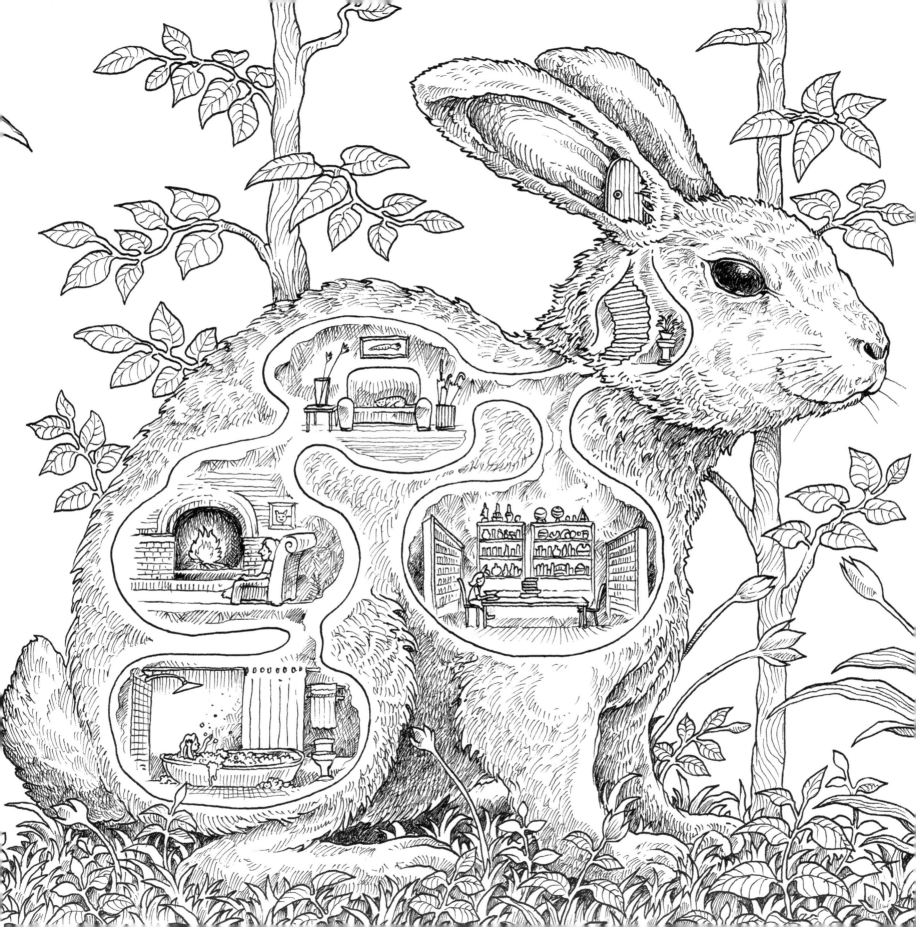

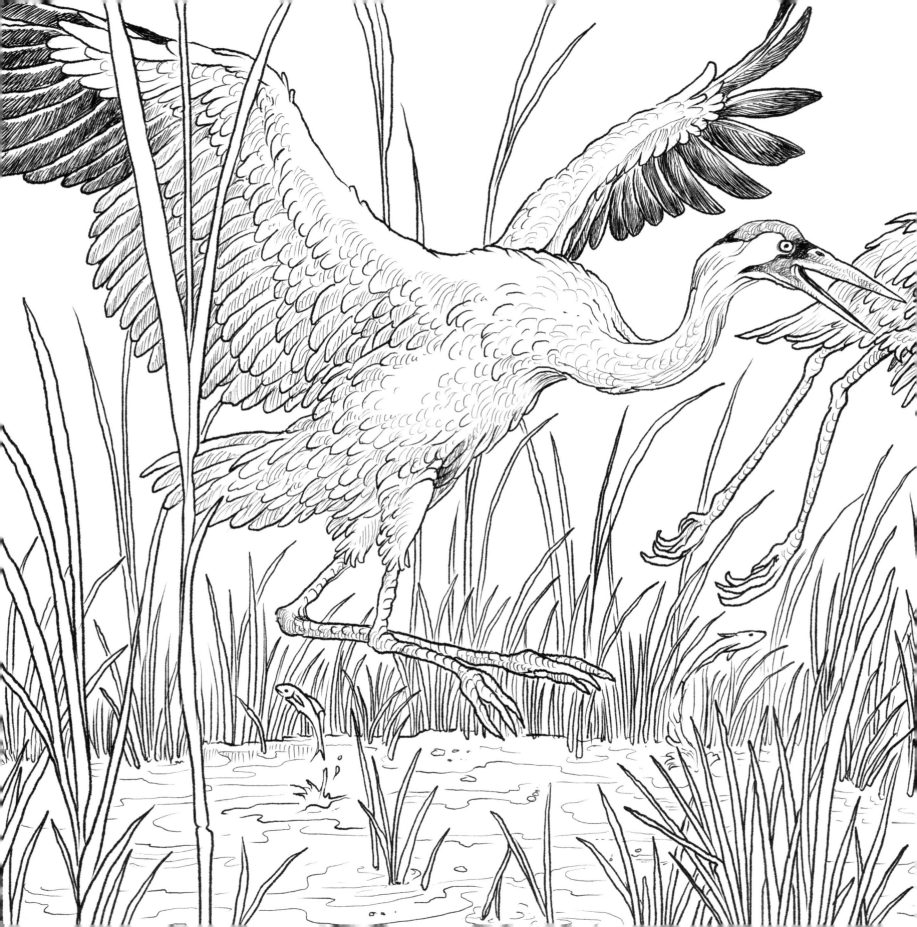

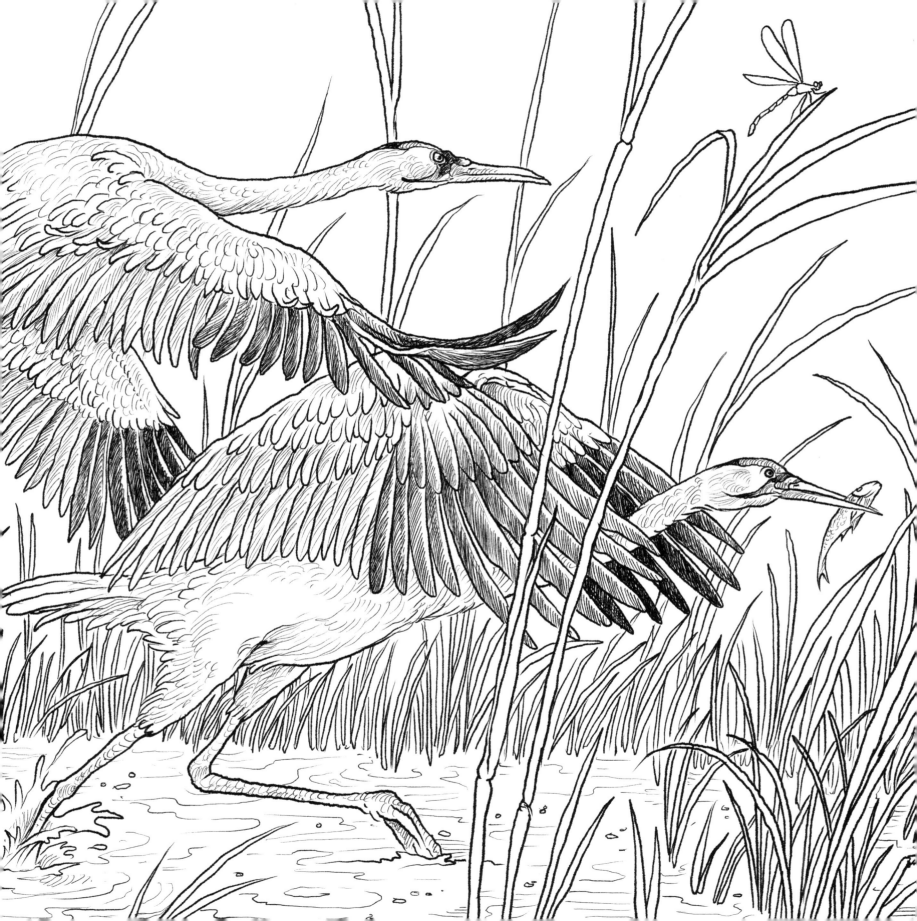

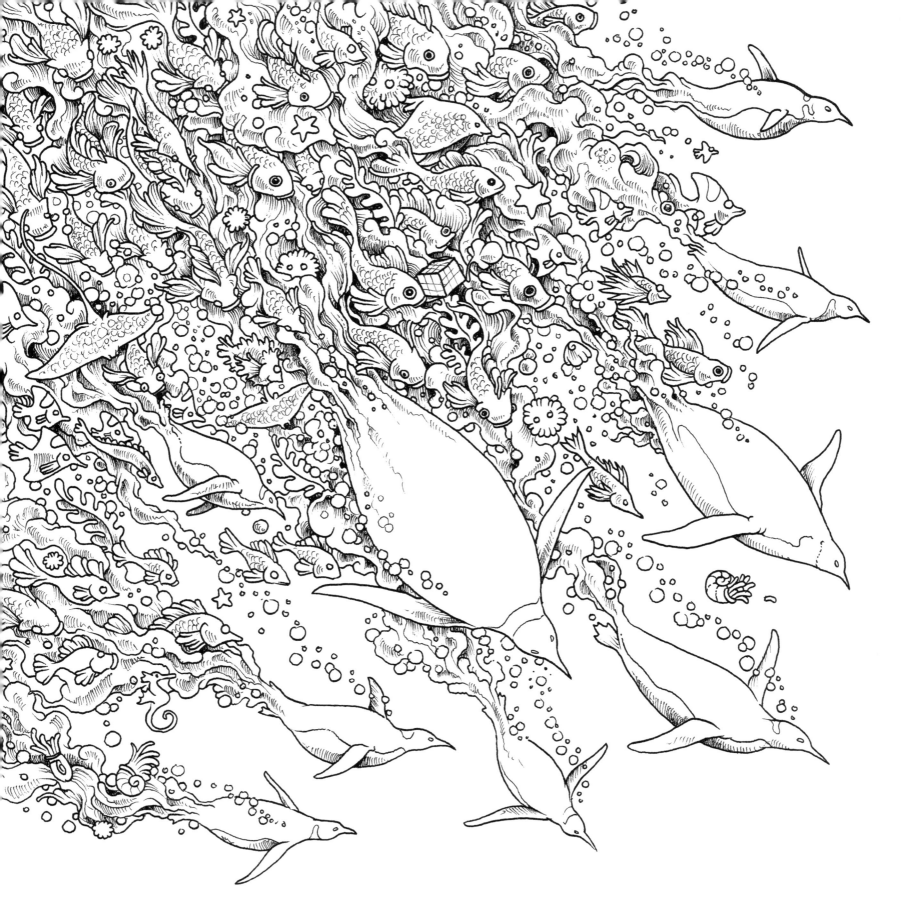

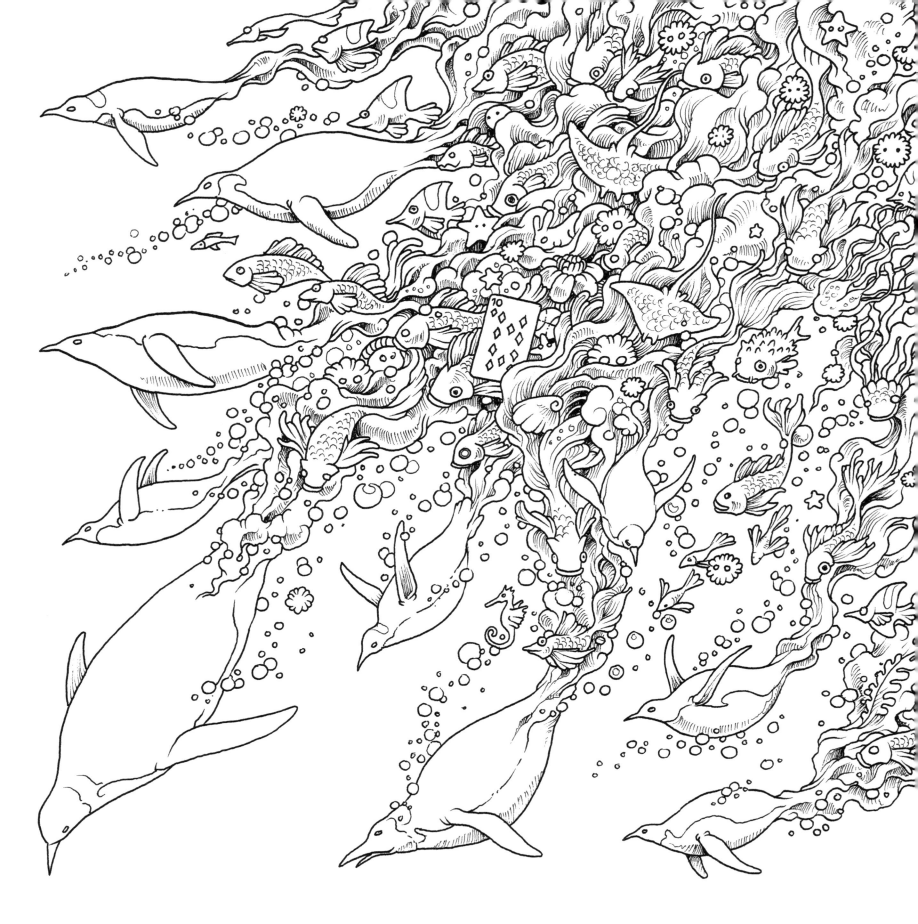

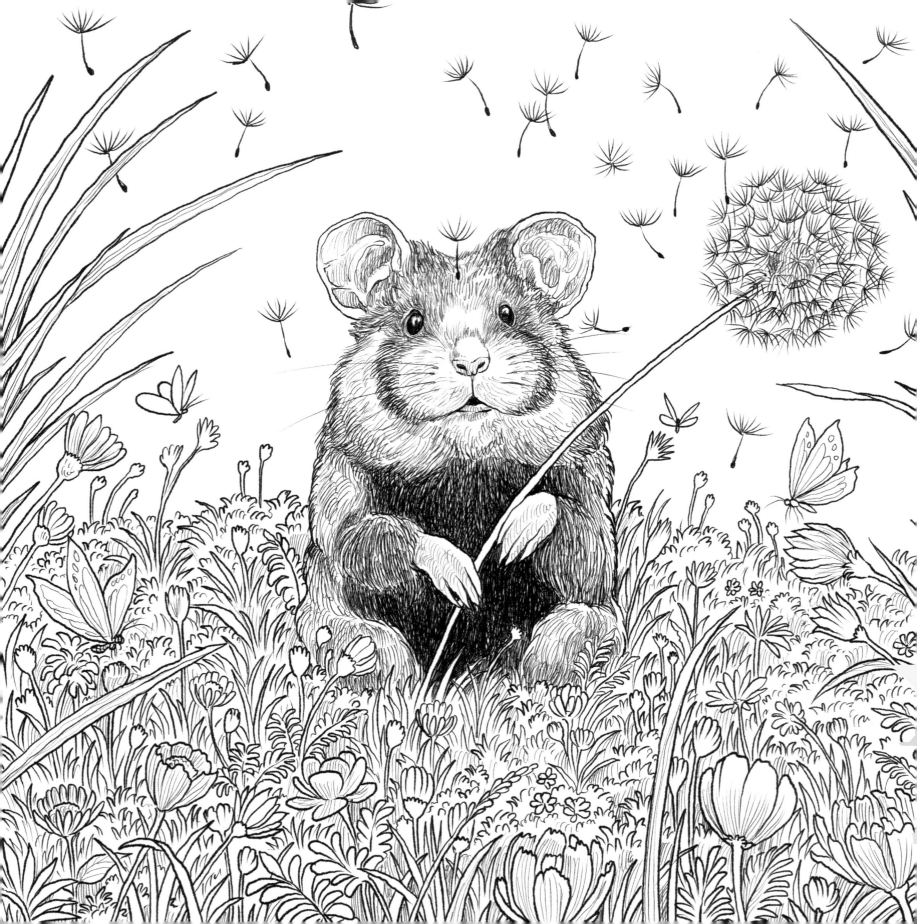

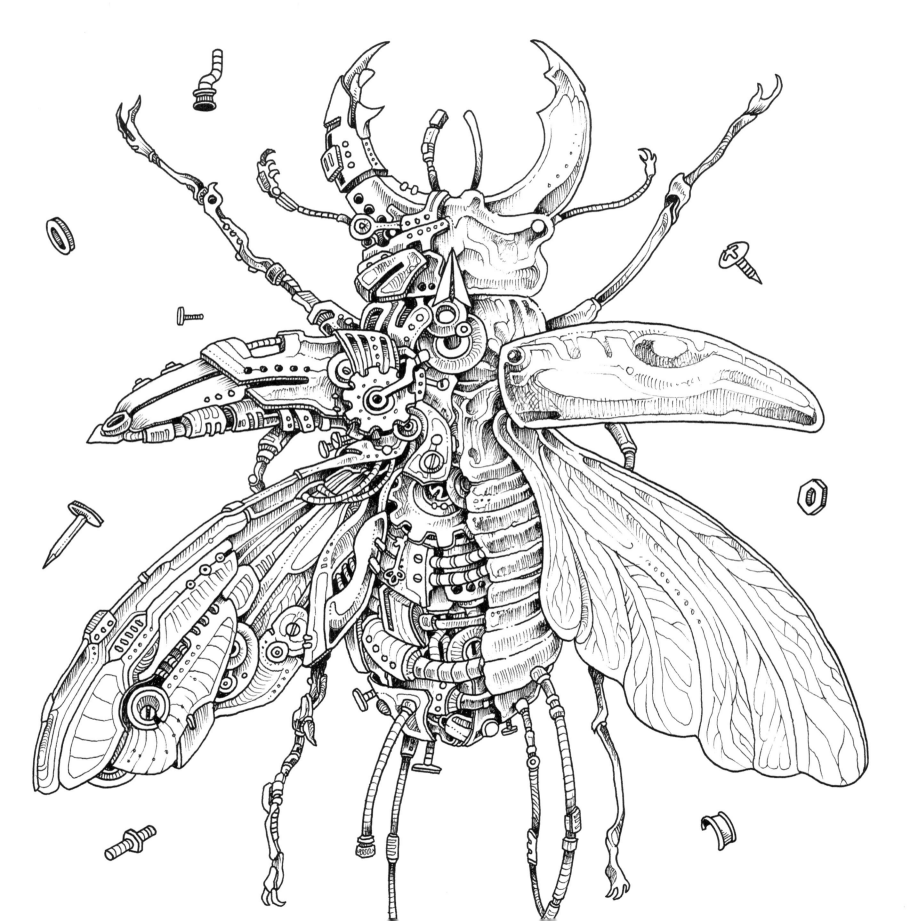

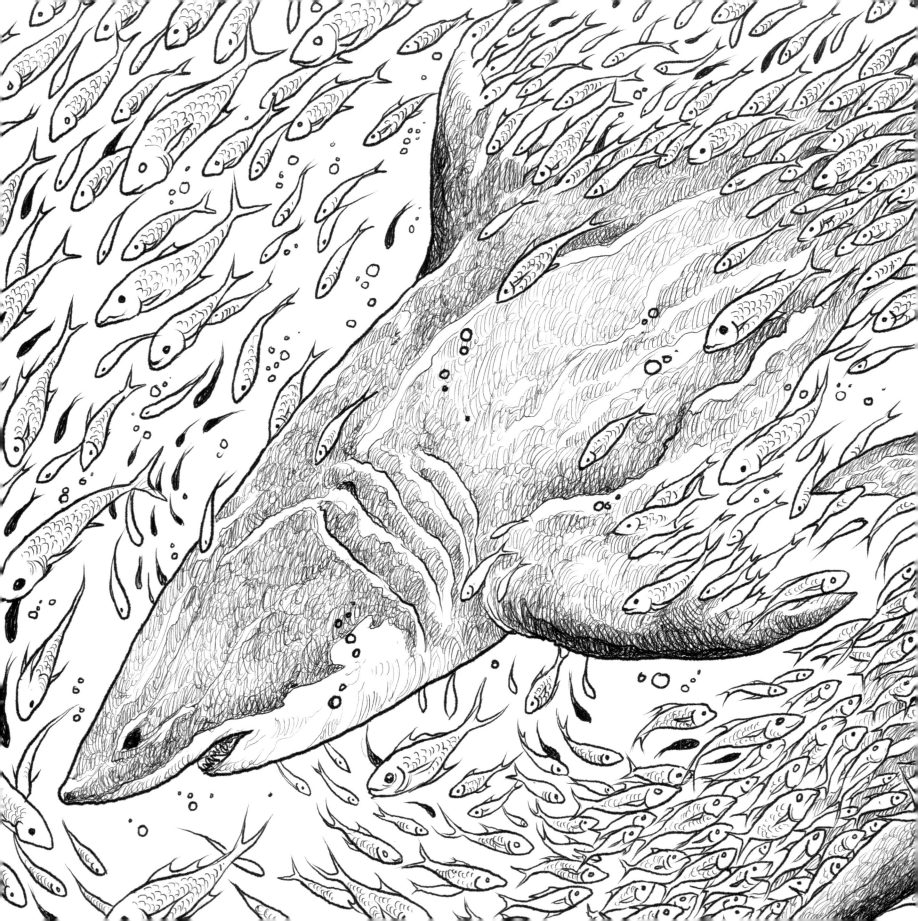

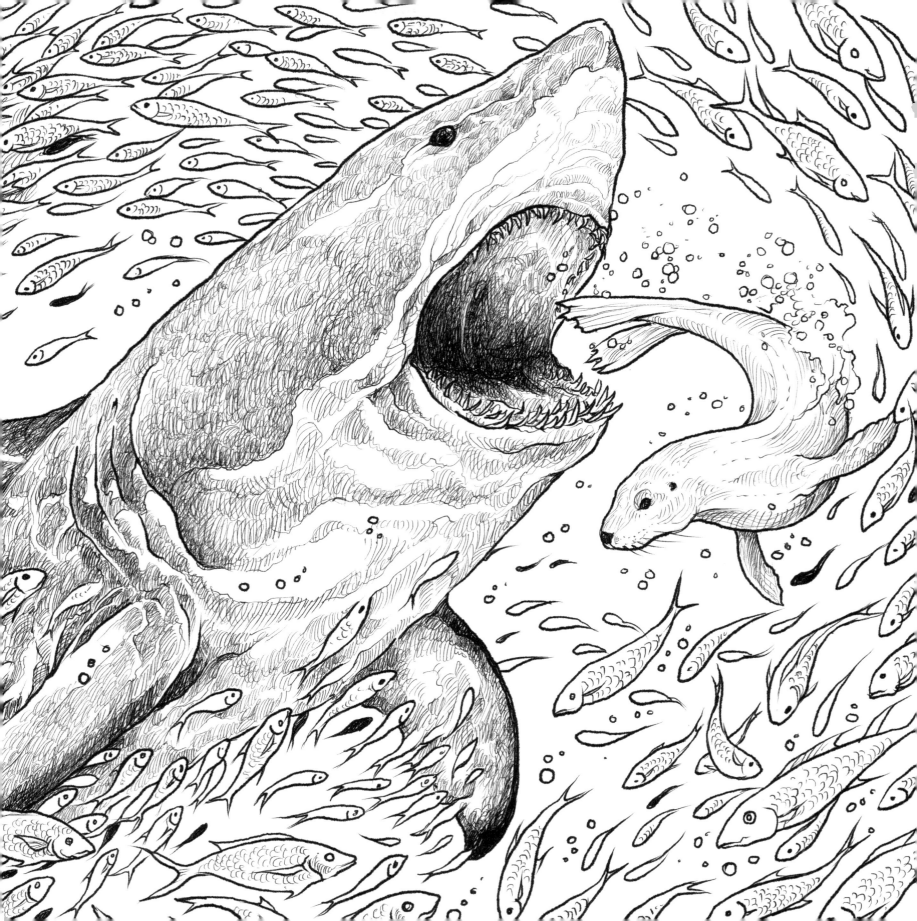

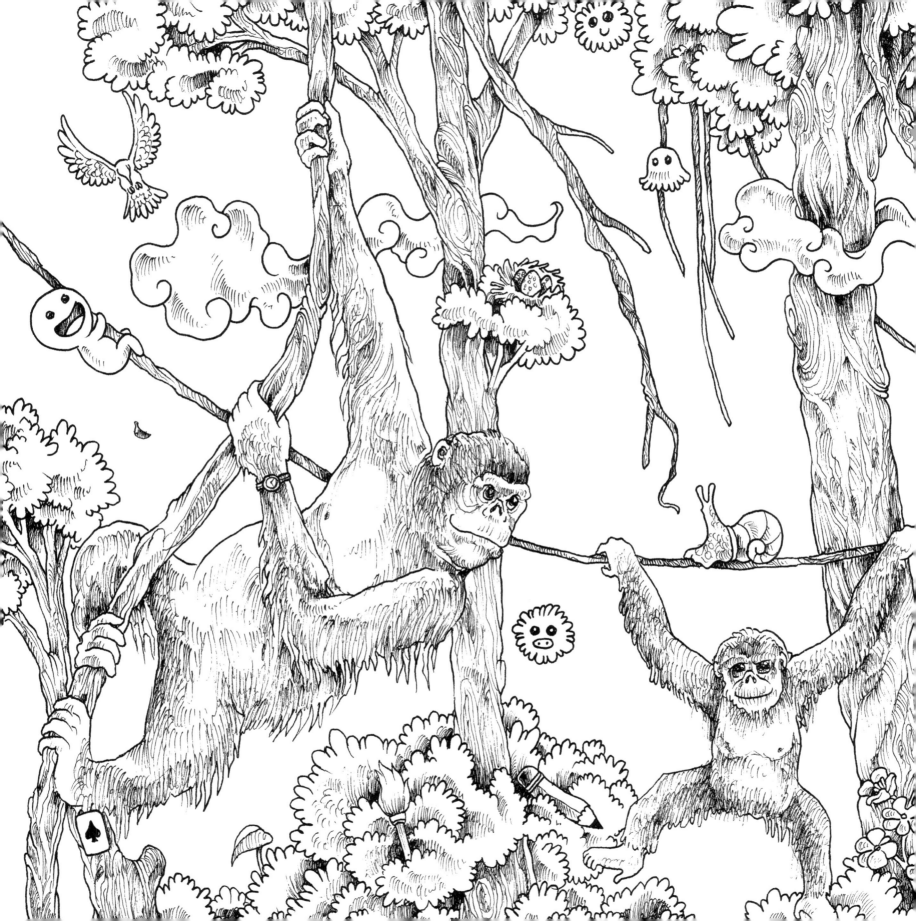

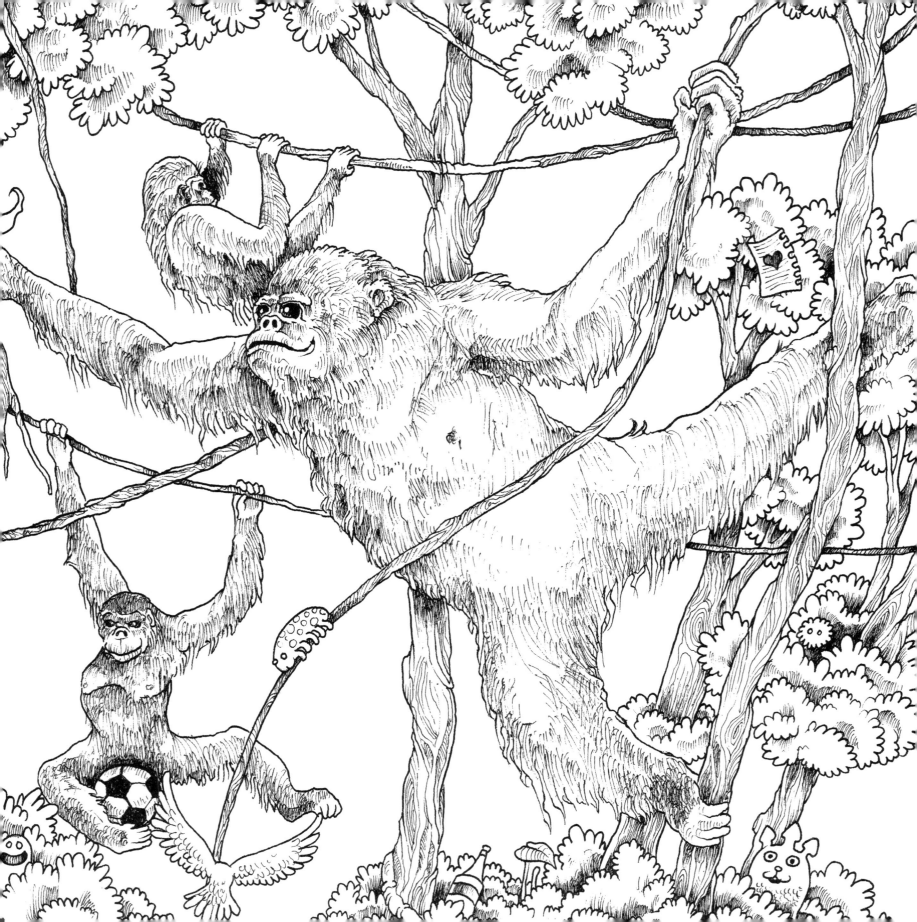

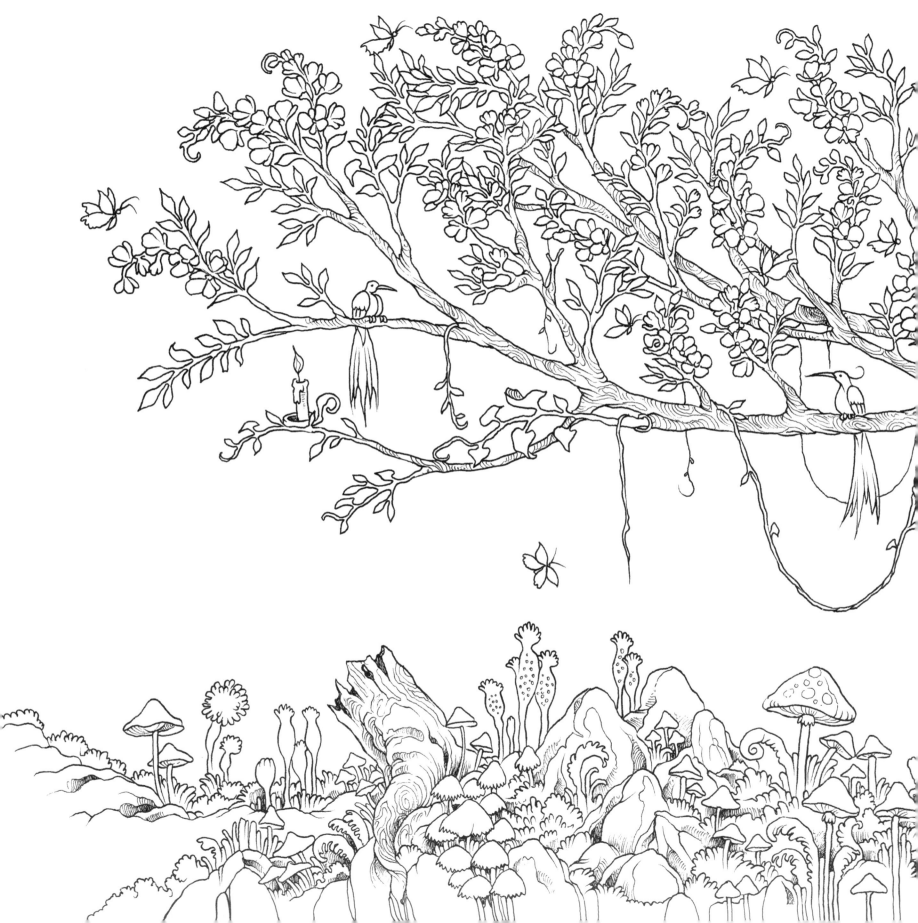

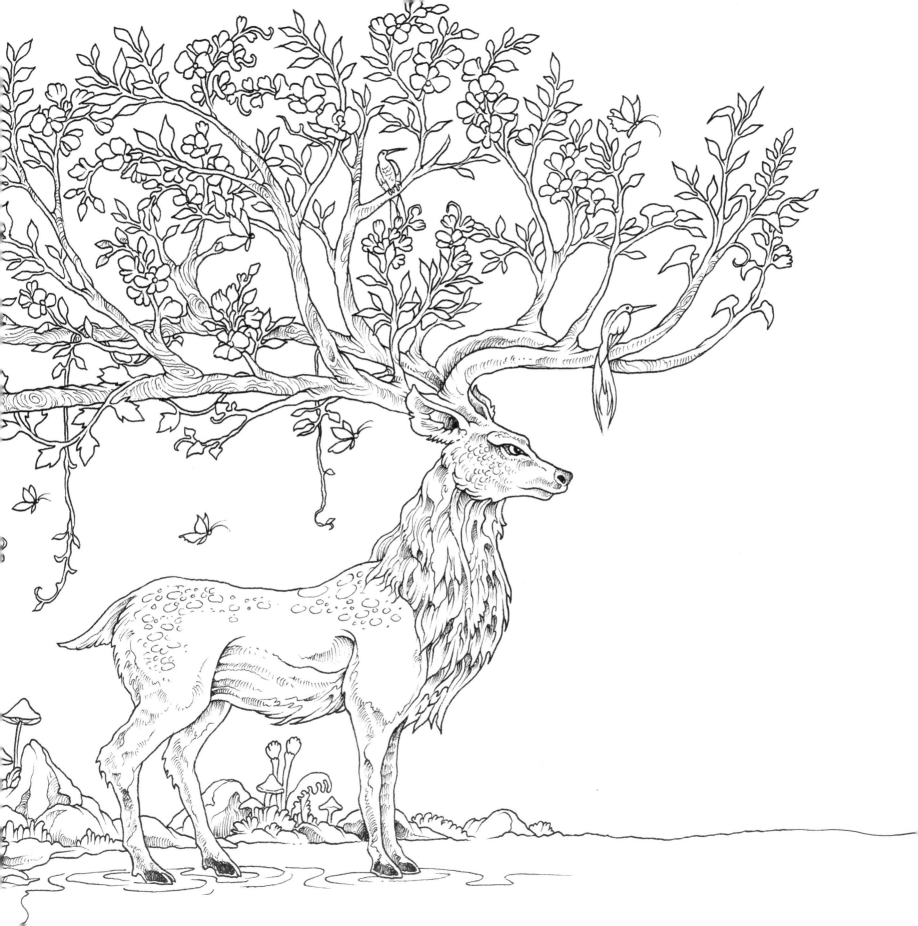

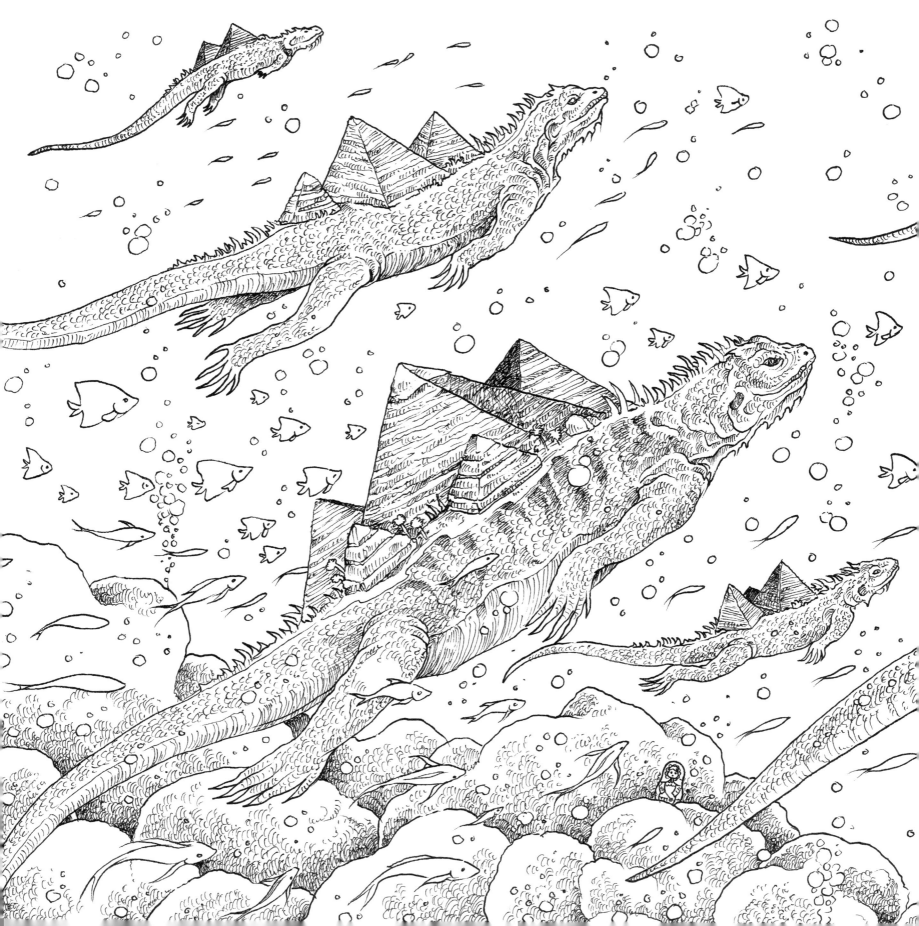

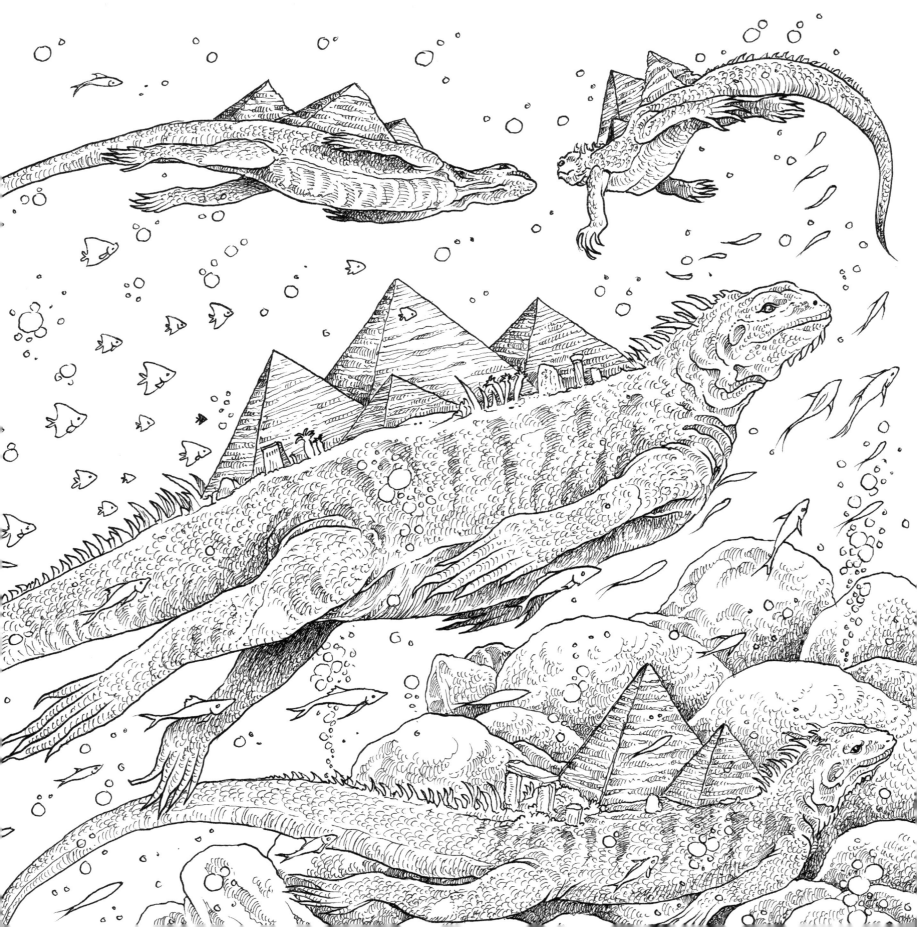

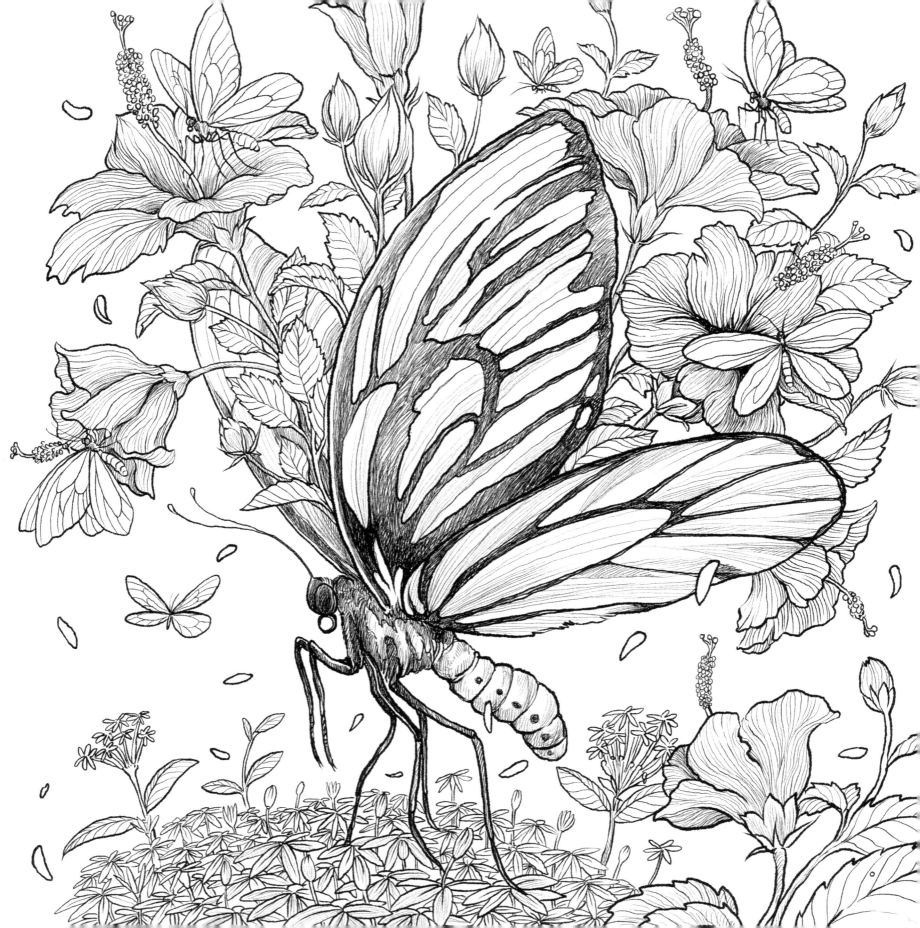

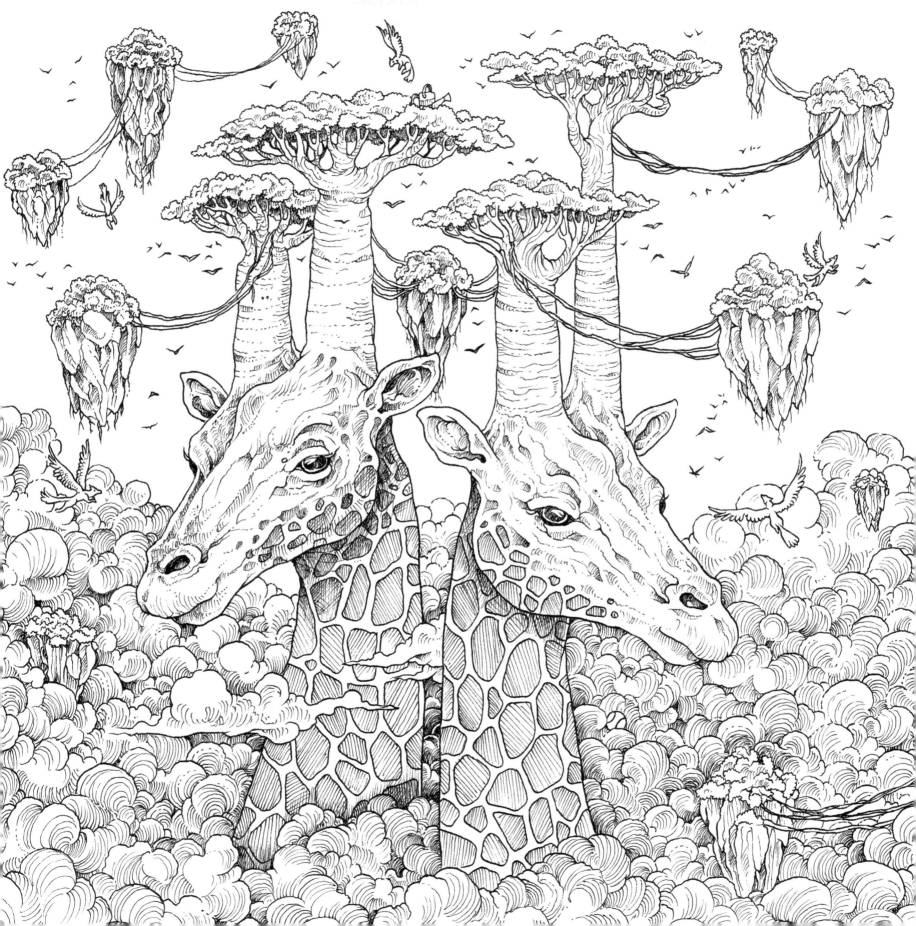

The illustrations in this book have been chosen from the spectacular works of Kerby Rosanes shown below. If you loved bringing these images to life with color, there's plenty more to discover.

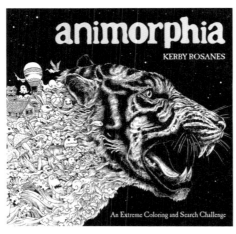

animorphia
KERBY ROSANES
An Extreme Coloring and Search Challenge

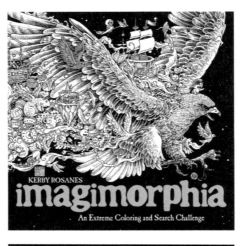

KERBY ROSANES
imagimorphia
An Extreme Coloring and Search Challenge

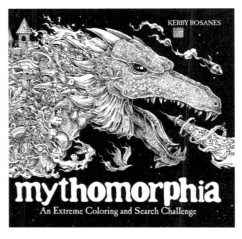

KERBY ROSANES
mythomorphia
An Extreme Coloring and Search Challenge

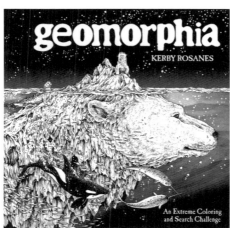

geomorphia
KERBY ROSANES
An Extreme Coloring and Search Challenge

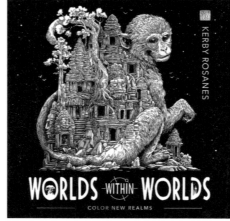

WORLDS WITHIN WORLDS
COLOR NEW REALMS
KERBY ROSANES

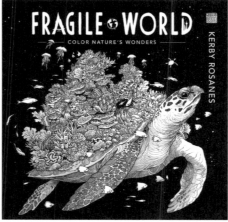

FRAGILE WORLD
COLOR NATURE'S WONDERS
KERBY ROSANES